WHEN YOU ARE
SINKING
BECOME A SUBMARINE

Winning through Wisdom and Creativity

To

Mr & Ms John Miller

With all my kind regards

KJK Choudary

Shimla

28.08.'07

WHEN YOU ARE SINKING BECOME A SUBMARINE

Winning through Wisdom and Creativity

Pavan Choudary

wisdom
tree

ISBN 81-8328-052-8

Published by
Wisdom Tree
4779/23 Ansari Road
Darya Ganj
New Delhi-110002
Ph.: 23247966/67/68

Published by Shobit Arya for Wisdom Tree; *edited by* Manju Gupta; *designed by* Kamal P. Jammual; *typeset at* Marks & Strokes, Delhi-110028 and *printed at* Print Perfect, New Delhi - 110064

CONTENTS

PART III: ENDURING BASES OF POWER

ACKNOWLEDGEMENTS

Before I acknowledge the people who helped me with the book, borrowing from the *namokaar* tradition of India, I would like to salute the five kinds of masters:

- *Arihantas*: Those who have no enemies — those who have conquered all opposing beings as well as discordant thoughts and have come to a state of total poise.

- *Siddhas*: Those who command Nature.

- *Acharyas*: Those whose thoughts, words and deeds are in perfect alignment.

- *Upadhyayas*: Those Acharyas who also teach others.

- *Sadhus*: All the great eternal souls.

I bow before them in deep gratitude and reverence.

I especially thank the *Upadhyayas*, whose thoughts paved the way for mine and from whose works I learnt a great deal. Standing at their feet, I have looked at their gigantic contributions with awe. Standing on their shoulders, I may have peeped further. To name some of these literary titans:

Osho;

Robert Greene and Joost Elffers;

Kabir;

Machiavelli;

Aristotle;

Chanakya;

Lao Tzu;

Fred Smith;

Francis Bacon;

Friedrich Nietzche;

Socrates;

Voltaire;

Karl Marx and

Max Weber.

I thank my parents who constantly inspire me — my mother especially, for helping me make this book. She did not only do the referencing and cross-referencing, but also edited it for me more than a couple of times.My father enriched the book through his novel ideas and warmed our home through his amiable presence.

I thank Stephane Regnault, Michele Boudereaux and Jean Zimmermann – fellow members of my board who entrusted to

me a laboratory called Vygon. We experimented with a multitude of ideas, executed the ones which we believed in and rode on their success. Several insights in this book come from these experiments. I consider myself fortunate to have got such a worldwide fraternity, such a team and such a company to work with.

I also thank all the other members of my *khandaan* (extended family), and my dear friends. A few of them have been the perennial springs of encouragement for this book: my sister Chandana and her family, Aasheesh, B.M. Saighal and family, Varun, Devna, Goldie and Shobhna, Ambar, Avishkaar, P.V.Rajgopal, Uday, Shakeel, Shrawan, Kishore, Sunil, Sanjay, Anamika, Aman, Rajeev, Suri, Yann, Himanshu, Rohit, Alpana, Julien, Gopal, Anand, Dhirendra, Vineet, Vikas, Deepak & team and Anu. Special thanks to my nephew Akash for editing and improving the manuscript, encouraging me with his many compliments and regaling me with his criticism.

Thanks, also, to Pankaj Khanna. It was in a conversation with him that we found the title of this book.

Finally, I thank Sadhna for putting me on to Shobit Arya, my publisher. His role in the making of this book was exceptional. I enjoyed his presence and support throughout the journey and, it seems, we'll travel together again.

INTRODUCTION

In the world of power, there are broadly two kinds of people — those for whom only ends matter, and those for whom means are as important as the ends. For the sake of simplicity, let us name the first type as Vile and the second type as Naive. In the struggle for power, sometimes Naive wins, but more often it is Vile.

VILE'S PROFILE

Vile has lots of ambition but little conscience — he is free of moral constraints, free to act the way he pleases. He doesn't have a public image to live up to. His overriding concern, at all times, is to achieve his objective. All he is faithful to is his ambition. He doesn't care much how his obsession for his objective makes him appear in the eyes of his fellow-men. He isn't sensitive or kind and for him, life isn't a picnic. It is sycophancy, it is intrigue and it is war. He often toadies up to the more powerful and is arrogant

with those who don't matter in his scheme of things. He believes in self-praise and encourages others to praise him.

He makes problems, that he has already solved, look more difficult than they actually were. He thrusts the part of the problem, that cannot be solved, on others. He changes his strategies to prevent other people from recognising them. He shifts his position and traverses indirect routes to keep other people from anticipating him. As I said, he is only faithful to his objective; thus he is formless. His form is determined by his objective. As his objective changes, so does his form. If he feels he can be victorious, he will arise. If he feels he will be defeated, he will desist. He has no principles, no scruples. He finds it safer to be heartless than mindless. He works without a conscience. He is true only to his objective and that is his source of strength.

In fact, there are two types of Viles — the first type is the schemer. His path is circuitous. He poses to be what he is not. He is a wolf masquerading as the sheep. He is the friendly thief. Many of his victims never realise that they have been robbed. Some of them do, but only when it is too late.

The second type is the intimidator. He uses force to make Naive prostate. He believes what can't be solved through force, needs more force. He belongs to the when-you've-got-them-by-the-balls-the-hearts-and-minds-will-follow school of thought. With time, he realises that Naive prefers to avoid a confrontation. This emboldens him and bolsters his confidence. His confidence multiplies his success rate. Gradually, he acquires an awesome reputation. Then, he rides roughshod over others.

Over time, if Vile is gifted, he masters the art of manipulation as well as the art of intimidation so that even his victims sing his praise.

This is when he becomes Super Vile. He projects himself as righteous and fair. He understands what makes Naive tick. He believes in the principle of reciprocity, but not in the traditional give and take. He believes in give and take and take and take.

NAIVE'S PROFILE

He is overburdened by his socialisation in early years. He is kind and compassionate and wishes to be seen as such. He is modest about his achievements. Means as well as ends matter to him.

He is respectful to his superiors as well as to his subordinates. He knows what he will stand for and what he will oppose since his conscience tells him that. He doesn't initially understand Vile, his tactics and what makes him tick. Over time he understands Vile but condones his wrongs, thinking and believing (fallaciously) that Vile's *karma* will catch up with him. Providence will prevail. That is when he becomes Super Naive. He doesn't realise that in some circumstances, to be good is to guarantee the triumph of evil. He doesn't understand when to duck and when to fire. He even fails to realise that once in a while he has to pick up the hatchet for his own good and for the sake of the good. Very often, he doesn't even have a hatchet.

This book is for him. It explains the games played by Vile and provides remedies to cope with them. It challenges Machiavelli's belief that a good man hasn't got a chance, and comes to ruin among the many who are not good.

The following pages elucidate, through logical and researched explanations, how the path of goodness coupled with creativity and wisdom is the only way to an enduring victory. The premises in the book are substantiated with real-life examples, which will serve as mnemonics to help the reader remember the underlying principles.

Unique insights are offered as to how to make your ship a submarine if it is sinking and how to build your castle with bricks that others have thrown at you. It also explains how wisdom helps one succeed, sustain his success and build enduring bases of power. Cross cultural in context, its relevance extends beyond business — in fact, to all walks of life. In many ways, it is a book of *universal* and *abiding* solutions.

VILE — HOW HE OPERATES

CREDIT POACHING

Shared information always creates the potential for poaching of credit.

In any transactional relationship, there is always the risk that information shared between parties for purposes specified in the contract may deliberately be used by the receiving party for purposes outside the contract, to its own benefit, and to the detriment of the party that provides the information.

American medical researcher, Dr Jonas Salk, announced the vaccine against polio on CBS national radio network, and two days later through an article published in the *Journal of the American Medical Association*. In doing so, he broke all protocol of the scientific community by going public with a discovery before showing it to the scientists, and took exclusive credit for the vaccine without acknowledging the contributions of those who had paved the way for his success. This disrespect for the

orthodoxies of his community left him isolated and frustrated in later years, and he found himself struggling for funding and cooperation.

Credit poaching happens everywhere — in the world of science, art, business, or in the theatres of sports, films or politics.

The book *Yes Prime Minister* by Jonathan Lynn and Antony Jay is a political satire at its finest. It exemplifies the battle between elected officials, whose terms are temporary but who want to make their mark in history books, and members of the civil service, whose jobs are permanent and who want things to stay the way they are.

The book continues the story of the popular British sitcom *Yes Minister's* main characters, who have all been elevated to higher positions. While James Hacker, Minister of Administrative Affairs, is mulling over the problem of Eurosausage, the Prime Minister has decided to step down at the end of the year, forcing an election in Hacker's party. Cabinet Secretary Sir Arnold Robinson is also retiring, giving the job to Sir Humphrey Appleby. Now, the question is: Who will get the Prime Minister's job?

The ideal candidate would be someone fully trained by the civil service, well liked, with no opinions of his own, no bright ideas, not intellectually committed, and without the strength to change anything. In a nutshell, Hacker! Once Hacker has been decided upon, the wheels are set in motion, the problems of Eurosausage are solved and, in the first vote, he is elected Prime Minister.

It is interesting to note how the problem of Eurosausage is used to propel Hacker to prime ministership. Bernard Wooley, who continues to be Hacker's private secretary, believes that a

solved Eurosausage problem is not going to catapult one into the leadership of the party. The public doesn't even know that the problem exists, so why should it care if it is solved? That's why Wooley decides he would first give the people the news of the disaster. They would love to get that information. Then, he would give them the news of the triumph a few days later. The Prime Minister would enjoy taking the credit, and there would be no danger of Hacker denying a favourable story just because it was not true. It is also decided that the Prime Minister would send the Foreign Secretary out on all tricky foreign missions, but would go abroad personally and hog the limelight if there was any glory to be earned. Just another example of credit poaching.

Credit poaching has several strokes. The ones most commonly used are outlined below.

Stroke A – **It's teamwork.** When the idea is not Vile's and there is no way he can plagiarise it, he labels it as 'teamwork'. The originator of the idea is thereby forgotten and Vile is taken to be the modest and generous leader, crediting his idea to the hard work of the team.

Stroke B – **The idea is raw. I will get back to you.** This stroke is a wedge technique, with the purpose of ascertaining if the creator of the idea will allow co-authorship or not. If the creator disallows co-authorship, Vile just keeps sitting on the idea, without allowing it to manifest. This way, if Vile does not gain credit for it, nobody does.

Stroke C – **Claiming posthumous credit.** This stroke is played by veteran Viles. All ideas of erstwhile stars of the team are passed off as their own. Since the intellectual property infringed upon does not have an owner to defend it, there is

little dispute over the issue. As a corollary of this stroke, the blame for the failure of ideas is conveniently dumped on to those who are no more on the scene.

Stroke D – **Doling out details of the success story more authentically than others.** When the beaming Vile furnishes in-depth details of his success story, the innocent audience concludes that he is indeed the father of the idea, for how else would he have access to such detailed descriptions? In this stroke, there is a liberal use of words, such as *us* and *we*, so that the clever Vile is also seen, by the audience, as being generous enough to share some credit with his team members. This trick of using the chorus style to sing a solo song also confuses his team members. The gullible among them might even think that he is highlighting their achievements. Not quite. He is establishing paternity over the idea.

Stroke E – **Defending the idea.** This stroke is a cousin to *Stroke D*. Over time, many successful ideas come under public scrutiny, since the causal relationship between an idea and its result is not always clear. On such occasions, the one who defends the idea comes across as its originator. Vile gallantly runs to such defence.

Stroke F – **Compartmentalisation and Implementation.** This stroke is all about secrecy and supremacy. Vile chooses not to reveal the modus operandi of implementation to anyone. He first compartmentalises the team and then briefs each part separately with limited details, thus keeping everybody dependent on him for the next-step information. He thus assumes the role and visibility of an indispensable leader.

Advice for Vile

- Survive on self-merit, if you wish to survive long.

- Forget about making an impression. Concentrate on contributing.

- *There are two kinds of people: those who do the work, and those who take the credit.* — Indira Gandhi

Advice for the Ruler

- Innovation usually threatens status quo. Use this understanding to reduce the political fallout of innovation.

- Let the originator of the innovation be the first person to endorse it.

- While appraising the performance of your team, lay special focus on innovation and have a formal mechanism to identify and reward the individual from whom an idea or initiative originates.

- Share credit. Shoulder blame.

PROMOTING SELF-PRAISE

Even the virtue-less, when praised by others, are considered
virtuous. And even Lord Indra is looked down upon when he
praises his own self.

— Hindu proverb

Out of the many paths to power, one is through hierarchical
authority. Hierarchical command is usually seen as legitimate in
organisations, and is almost taken for granted. We seldom question
or challenge the power of those at higher levels. But there are
quite a few problems in use of hierarchy as the only means for
getting things done.

A serious problem with implementation through hierarchical
authority is that since authority is vested in a single individual,
the organisation can face grave difficulties if that person's insight
or leadership begins to fail. The entire structure of the organisation
can collapse if the person at the top of the pyramid, whose
commands are being carried out, errs.

This was precisely what happened when Robert Fomon, Chief Executive Officer of E.F. Hutton, ruled the firm through a rigid hierarchy of centralised power. *More of a monarch than a chief executive, Fomon appointed cronies and 'yes men' as managers and directors of Hutton to insulate himself from the challenges of the real world.* Consequently, when the brokerage industry changed in the 1980s, Hutton did not, as no one in the firm could challenge Fomon to respond to new realities. Eventually, the company ceased to exist as an independent entity.

Promoting self-praise to build one's own authority is an allied game to credit poaching. Just as Vile cannot directly grab other people's credit for the danger of being seen as a poacher, he cannot blow his own trumpet for the fear of looking vain. So he needs someone else to toot his horn.

To get others to praise him, he uses the following strokes:

Stroke A – **Smiling when praised.** Vile smiles when he is praised. He leaves no doubt that he likes it. This way more praise comes his way.

Stroke B – **Tell them what we did.** This stroke is used to encourage a subordinate to praise one's deeds before others. It is an open exhortation to hear a eulogy.

Stroke C – **Rewarding sycophancy.** This is one of the deadliest strokes of Vile, wherein he labels flattery as positive attitude. He deliberately rewards the sycophant with perks such as a bigger office, carpeted floor, direct telephone line, chauffeur and promotions, all of which constitute the physical indicators of power.

Once this stroke is played, the message, 'lick to leap' goes loud and clear to all the intelligent employees. Since an

employee's performance at flattering is now directly proportionate to his growth in the organisation, the quality, quantum and frequency of praise for Vile rise up tremendously.

Advice for Naive

- Two stone-cutters were asked what they were doing. While the first said, "I'm cutting stone", the second replied, "I'm on a team that's building a cathedral."

- When people brag, stay silent.

Advice for Vile

- Don't be seduced by self importance. It's not the whistle that pulls the train.

- Never speak well of yourself if you wish your men to speak well of you.

- Inauspicious events arise when you detest hearing about your errors.

- When you start crowing, you stop growing.

Advice for the Ruler

- Prevent sycophancy in your organisation by giving more recognition to teams than to individuals.

- When the general brags, his assistants will have few attainments.

DIVIDING TO RULE AND TO STAY UN-RULED

A despot easily forgives his subjects for not loving him, provided they do not love each other.

— Alexis de Tocqueville

Zia-ul-Haq became the President of Pakistan after overthrowing President Zulfikar Ali Bhutto in a *coup d'état*. He prevented any unity to take place in his second line by having all the members accompany him on all his foreign tours. This way he ensured that he would not get overthrown in his own absence.

The objective of this game is to sustain one's rule. Following are the classical strokes of the game:

Stroke A – **Dangling a carrot but for a few.** In this stroke, Vile makes interests clash by showing that there is a carrot, but not for everyone. The carrot may be extremely intangible and may just mean getting into Vile's good books. The contenders for the carrot then start fighting among themselves. Thus, Vile's reign continues unquestioned as long as their fights last.

Stroke B – **Using one to screw the other.** People are instigated to attack one another, seemingly in the organisation's interest. Vile justifies this stroke saying that the existence of this internal strife not only hones and polishes people but also enhances organisational efficiency.

Stroke C – **The 'Complaint' stroke.** This involves telling one subordinate what the other subordinate said about his work and conduct. This usually makes the first subordinate react and speak ill of the alleged accuser. Vile then quotes him with exaggeration to the latter, thus creating a sure fission between the two.

Stroke D – **I want transparency.** Vile insists on knowing whatever transpires between his people, what they say or do among themselves. The subordinates, thus encouraged, report every little misdemeanour of their colleagues and thereafter can never unite to pose a threat to Vile. If bickering goes on beneath Vile, he plays judge, thus consolidating his power and elevating his stature.

Stroke E – **Greeting a complaint with a 'this is very serious' gesture.** This is a Super Vile Stroke in which, whenever a subordinate approaches him with complaints about other colleagues, his complaints are greeted with such serious concern that he is encouraged to go on sneaking. Vile cleverly refrains from making any verbal comments, as he knows he can be quoted/misquoted. He communicates in this case through gestures or body language as these carry no risk. In other words, he commits the crime but leaves no evidence.

The 'dividing to stay un-ruled' stroke. A word here must be said about another Super Vile Stroke. I have noticed this stroke being played in the higher echelons of power and would like to christen it as *dividing to stay un-ruled stroke.*

But first a fable…

The kites and the crows in a forest reach an agreement to take halves in every prey they catch. One day, when they come across a wounded fox, the crows decide to eat the upper half of the fox, while the kites agree to pick on the lower half. The wounded fox suggests to the kites that since they are superior to the crows, they should take the upper half of his body. This advice sets the kites and the crows quarrelling, a bloody battle ensues between the two parties which leave no survivors. All the kites and the crows end up dead. The cunning fox then feeds on the dead kites and crows, and shrewdly observes that the weak benefit by the quarrels of the mighty.

Super Vile does not just divide those below him. *He divides the ones above him too, for freedom from accountability.* In this stroke, Super Vile fans the friction existing amongst his superiors. By ensuring that his seniors do not see eye to eye with each other, his accountability is reduced and each superior tries to woo him to his side. He thrives on the animosity he has generated between his seniors. If at any point, the fire starts extinguishing, he refuels it.

Advice for Vile

- By dividing to rule, you actually display a lack of faith in your own power, and thereby dilute your authority. When you divide and rule, your subordinates somehow unmistakingly receive the signal that you are not strong enough to deal with them if they are united. This makes you lose your awe.

Advice for the Ruler

- The divide-and-rule tactic permanently scars the organisation. It is true that all polishing results from friction, but too much friction erodes the very soul of the organisation. Salutary doses of friction should be allowed to arise from a spirit of healthy competition. The friction generated thus will polish, not corrode.

THUMBSCREWING

Everyone has a weakness, a gap in the castle wall.

That weakness is an insecurity, an uncontrollable emotion or need.

It can also be a small secret pleasure.

— Robert Greene and Joost Elffers

Irving Paul Swifty Lazar (1907-1993) was a legendary Hollywood super agent. Born in Brooklyn, New York, he was inarguably the most flamboyantly famous agent of his time. He was a tiny man, remembered visually for his bald head, enormous black-rimmed glasses, and a tremendous snob who prided himself on his ability to get huge commissions for his clients without having seen or read their work. His clients varied from Noel Coward, Cole Porter and Joan Collins to Madonna and Truman Capote.

Irving Lazar was once anxious to sell a play to studio mogul, Jack Warner. Over a long meeting with Warner, he mentioned

nothing about the intended sale. He decided to wait until the next weekend when Warner would go to Palm Springs for his weekend baths at the spa. Warner, Lazar knew, was eighty-years old, very vain, and didn't like people to see him naked. Lazar would also go naked but he did not care who saw him. Warner cared. So Lazar decided he would walk up to him naked and start to talk about the deal. Warner would be embarrassed, would want to get away from the discussion, and the easiest way out for him to do that would be to say 'yes'. He knew if he said 'no', Lazar would persist with his pitch and hang around him longer.

Two weeks later, the world read about the acquisition of this particular property by Warner Brothers. The deal was struck just the way Lazar had anticipated.

The above example of thumbscrewing is a Super Vile Stroke. The clever Vile discovers each man's thumbscrew. This stroke has two variants — the first involves making use of someone's weakness, soft spot or even vanity. Vile, adept at recognising what makes Naive tick, looks for a pattern in Naive's behaviour, and then provides a stimulus to elicit a particular response from Naive. Naive bites the bullet and Vile reaches his objective.

Once Vile A asked one of his juniors B to enter a negative remark on the performance appraisal form of B's junior, C. B entered a mild criticism and brought it up to A, who looked at the comment disapprovingly, but kept the form in his drawer, saying, "I think I will need to make the criticism sharper," knowing fully well that he could not edit B's comments. For the next couple of days, he did not talk to B about it. As the weekend was approaching, A called B to his cabin on some pretext, brought the performance appraisal form out from his drawer in full view of B and kept on doing his work. He used the art of silence very

effectively while providing the visual stimulus to prompt the desired response from B.

Quite expectedly, B (in his desire to please A) spurted out, "You found my comment wanting? I think you are not satisfied with it. Let me take the form and make the criticism sharper." A nodded, a smile of victory in his eyes for having rightly read his brooding and eager-to-please subordinate and thus triggering him to do what he wanted.

The second variation of the thumbscrewing stroke involves either making someone commit a mistake or involve the other in your wrongdoing. In this stroke, Vile attracts his victims to a crooked scheme, creates a bond of blood and guilt with them by making them participate in his deception, and thereon manipulates them. Serge Stavisky, the French con-artist of the 1920s, played this stroke when he so entangled the government in his scams that the government could not initiate any enquiries against him.

An editor (Vile) of a noted newsmagazine is reported to have said, "As I don't trust any owners I have worked with, in the first few months of my stint with any of them, I make them commit some wrong and then help them hide it. These unscrupulous owners have therefore always behaved themselves with me, knowing well that I hide a skeleton of their misdeeds in my cupboard. You know, you have to be a wolf to control wolves."

A clever tactic to implicate those who can harm you most, when you fail.

PSYCHING

A man's character is his fate.

— Heraclitus

The objective of psyching is to scare people, to instil respect through fear. The short-term usefulness of fear as a tool in ruling is unquestioned, but Vile (drunk on power) sometimes does not realise that the quality of fear generated is also important. The ruled must feel that punishment for a wrongdoing will indeed ensue. But the purpose of the punishment will be to correct the wrongdoer, not to harass him. In fact, punishment should begin only when discipline fails.

Spreading of wanton fear leads almost always to a backlash. Realising this, Super Vile, when mad with one, is often extra civilised with the rest.

Vile uses several of the following strokes to psyche people and generate power.

Stroke A – **It is all a matter of perception.** The most important thing that Vile keeps in mind is that power is a matter of perception. If you think you have it, you have it. Coming out of the super boss's room and firing is, therefore, one of the favourite ploys he uses. Because Vile's meeting with the super boss has immediately preceded the firing, the fired upon assumes that the super boss is channelling his anger through Vile.

Often, when he gets a whiff of the forthcoming decision, he acts as if he is the one taking the decision or is, at least, instrumental in making it come to pass. Sometimes Vile insists only he (among the seniors) be addressed in a particular fashion. This way he sharpens the hierarchy and leaves people with no doubt as to where he stands.

The following is what Patrick French, in his book *Liberty or Death*, says about one of the early reasons for the Gandhi-Jinnah rift:

Jinnah thought Gandhi's tactics were turning a political campaign into 'an essentially spiritual movement'. As he stalked up to the platform, he was howled down with cries of 'shame', and berated for referring to his opponent as 'Mr Gandhi'. 'No,' howled the audience, 'Mahatma Gandhi.' It is notable that there is no report of the Mahatma rebuking his disciples. So it was that the proponent of Hindu-Muslim unity and author of the Lucknow Pact was hounded from the Congress meeting. As his biographer has written: 'He left central India with Ruttie by the next train, the searing memory of his defeat at Nagpur permanently emblazoned on his brain. (In pre- independent India, 'Mr' as a salutation for Gandhi was considered less respectful than 'Mahatma'. Perhaps, even highly evolved men like Gandhi were not immune to the temptation of reverence.)

A struggle for power was witnessed within the Kennedy administration, in the early 1960s, between Secretary of State, Dean Rusk, and McGeorge Bundy, the Special Assistant to the President for National Security Affairs. Bundy was the finest example of a special breed of men called 'establishment men', whose loyalty was to themselves and to their creed. He began to build his own power by enrolling others like him in the elite staff and in his informal inner network of friends in the government.

Rusk resented the growing profile and power of Bundy and his staff, so he complained about it often. However, Rusk's complaining served Bundy's interests well. Bundy did not worry about rumours of his growing power and influence. He delighted in them, knowing that the reputation that 'you are the man to see' feeds on itself, and makes you even more sought after.

After all, it's perceptions that matter.

Stroke B – **Browbeating.** This stroke is based on the belief that an attitude of power generates it, and an under-use of power makes one lose it. Thus, even when Vile's power position is under threat, he continues to fire his guns on and off, just to give an impression that he still wields some power that permits him to behave this way. This tactic keeps his power muscles oiled, and the affronted ones feel that Vile still enjoys some hidden support.

Such psyching was demonstrated by William Paley (1901-1990), the US media executive of CBS. He was the unrivalled godfather of American broadcasting — a visionary who steered the development of radio and ushered in the medium of television. Fabulously wealthy and notoriously despotic, Paley bought CBS in 1929, building it from a failing network of twenty-two radio stations into a vast broadcasting empire with hundreds

of radio and television affiliates. Almost until he died from a heart attack at 89, he kept a close eye on all areas of CBS's broadcast division, paying as much attention to programming as to business. The CBS news anchorman Dan Rather, after learning of Paley's death, said, "He was a giant of 20th-century business, a man committed to excellence. Despite his diminishing share of the company, Paley acted the omnipotent owner. If he wanted to explain something, he did it; if he chose not to, he didn't. His imperious conduct made people automatically regard him as the boss."

Stroke C – **Making them wait**. Another classic stroke used to psyche others (especially outsiders) is to make them wait. The deliberate and open use of delay (which is often made to appear accidental) is used as a symbol of their power. Vile also chooses to make others wait for his arrival. By being late, he draws attention to himself and forces others to consider the implicit power he has over them. If the person being made to wait himself happens to be a heavyweight, he thinks Vile must be heavier still since he can afford to make people such as himself wait. This tactic further increases the power perception of Vile.

Super Vile understands that it is not in his best interest to be commonly seen by people, since power is directly associated with an individual's scarcity as a social resource, and thereby, with his value as a member of a social unit. Therefore, Vile makes scarce public appearances and, through this scarcity, tries to heighten his importance.

One classic example of using delay as a tactic to acquire more power was Henry Kissinger's, the National Security Advisor in the Nixon administration.

From the beginning, it was clear to Kissinger that one of Nixon's top aide, H.R. Halderman, was going to wield a lot of power and influence. So the prime issue for Kissinger was to ensure that he was not quite subservient to Halderman. Halderman, who from the very beginning, wanted to control everything, soon demanded that the meetings with Nixon be preceded by short planning sessions in his office. Kissinger started to skip these meetings right away, by just being late. He used the tactic of arriving late to avoid the meetings and finally this tactic helped him get what he wanted — private audiences with the President. In his struggle to wriggle out of Halderman's control, he used the technique of delay very effectively.

Stroke D – **Name-dropping.** This technique is used very successfully to show Vile's proximity to the seat of power. One middle-level manager, whenever complimented for his shirt or tie by his peers or juniors, used to say that it is a present from the owner of the company. This technique also has a twin benefit. If the impression that the one in power likes or is happy with Vile is conveyed below, Vile's detractors will hesitate in criticising him before his seniors.

Stroke E – **Gory story-telling.** Vile lets the grapevine flow with lucid tales of what he did to others when the going got rough. With such stories doing the rounds, any real challenger's ambition to cross swords with Vile gets subdued.

Stroke F – **Positioning oneself as 'simply crazy'.** Vile depicts himself as crazy, so that 'normal' people don't cross his way. This stroke helps him to get away with a lot.

Stroke G – **Under-delegation.** Vile often rushes out of the office leaving half-instructed people in his wake. By not leaving

proper instructions and guidelines for the unprepared and unknowledgeable employees, he ensures that a series of mistakes are made in his absence. Upon return to the office, he raises hell about all that has gone wrong.

Stroke H – **Using telephony.** Vile relishes using telephones as psyching instruments. The objective is to give a false impression of power.

A young businessman rents a beautiful office and has it well furnished. Then, he sees a man enter the outer office. Pretending to appear busy, the businessman picks up the phone and starts to show he has a big deal coming. He throws huge figures and makes giant commitments. Finally, he hangs up and asks the visitor, "Can I help you?" The visitor replies, "Sure. I've come to install the phone!"

Phone Psyching Stroke 1 – Here the trick lies in showing to the onlooker that the caller at the other end of the line is being reprimanded or at least being cold shouldered. Actually, the caller may be reacting aggressively, but since the onlooker can hear only what Vile says and not what is being uttered on the earpiece, Vile plays this game effectively.

Phone Psyching Stroke 2 – Vile cherry-picks the words the person on the other end of the phone is uttering and repeats it to impress the audience around him. Example: "I summoned him to my ranch."

Of course, if a telecon is not going his way and Vile wants to suddenly terminate it, he uses another trick. He hangs up not when the guy on the other end of the line is talking but when Vile himself is talking. This makes the caller feel that the line must have got disconnected.

Phone Psyching Stroke 3 – In this stroke, Vile makes his confidant call him in the middle of a meeting, who is pre-briefed as to what to say. For obvious reasons, Vile may even choose to use the speakerphone in such a situation.

Phone Psyching Stroke 4 – Sometimes Vile may even ask the onlooker to leave the room, while he takes an unimportant call. This is done just to highlight his aura viz-a-viz the onlooker and project a non-confidential telephone conversation as being extremely confidential.

Most of the psyching games do yield short-term benefits, but it is usually only a matter of time — the world eventually spots one's dark secrets. This is precisely what happened to Richard Nixon, the most controversial American President, when one of the most dramatic conspiracies of the 20th century, the Watergate Scandal, came to light.

Despite Nixon's repeated denial of any connection to Watergate, dramatic secret tape recordings of White House conversations provided evidence of his role in the cover-up and exposed the Nixon administration. Some say Nixon lost his position primarily because he lost the respect of the American public, for the language used in the tapes. It was not the language of political discussions, but the abusive language of drunkards.

Under threat of impeachment, Nixon became the first American President ever to resign. He died as an epitome of American political tragedy.

Advice for Vile

- *Those wearing battle armour do not bow. Those in war chariots need not observe forms of propriety. Those manning fortifications do not scurry. In times of danger (war), one does not pay attention to seniority.* — Ssu-Ma Fa 2

- *People count up the faults of those who are keeping them waiting.* — French proverb

- Good manners make for good memories. Bad manners make for goodbyes.

 — Al Pacino in *People I Know*

Advice for the Ruler

- You can't expect your servants to go to battle, so don't make servants of your soldiers.

CALCULATING AND HAWKING

A calculating Vile is only true to his objective. Every transaction he engages in is measured in terms of what he gains out of it, either in the present or in the future. His shrewd insight helps him gauge, with sufficient accuracy the hidden privileges that can accrue in the future from people he is interacting with. To those who are currently under the weather, but by virtue of their position/service are likely to return to a position of power, Vile highlights his undying loyalty. He tries his best to deepen the bonds of friendship with them, as he can smell fair weather just round the corner. The highly developed weathercock in him tells him so. Even though he repeatedly proclaims that he is not just a fair-weather friend, that's precisely what he is — a fair-weather friend! Anyone who doesn't fit in his numerical analysis of profit and gain is considered (and treated like) a waste of time.

Not only does Vile calculate all the time, he hawks

all the time. He is a shrewd salesman who knows that the world helps those who don't need help, but can return others' favours.

Thus, he goes on undeterred in his task of helping others solely to entitle himself to their favours. He prepares a strong candidature for himself by the following strokes:

Stroke A – **Hawking his contacts.** Vile tells others about his illustrious friends and his intimacy with them. In fact, the more advanced Vile tells others what he could get done for himself or for someone else through his contacts. He even keeps himself surrounded by people who have some celebrity value, and from these he makes sure not to beg for favours. They are there just so he can tell others the class of people who keep his company. By showing his closeness to celebrities, he hopes to elicit the awe these power centres command in the society.

A hawking Super Vile attends the funeral of any influential person, even if he didn't know the person while he was alive. Attending such funerals gives him an opportunity to be seen in the company of other influential people (who come to mourn the death) and sometimes even to get to know them. And the only person who could conclusively say that Vile didn't know the deceased is no more!

Stroke B – **Hawking his wealth.** Vile knows that the most tangible barometer of success is wealth. He publicises his growing wealth. The advanced Vile connects his acquisitions with his impressive career plans and puts it across more subtly, yet with greater impact.

Having said all that about calculating and hawking, I must add that I see nothing wrong in someone's desire to advance socially. The problem comes when this desire so consumes him

that this social climber starts living on the staircase. By hook or by crook, and mostly by crook, social climbing is all he does.

Advice for Vile

- Life is not mathematics. It is poetry. It doesn't unfold like an arithmetic equation. It unravels in stanzas. Outcomes in life are not affected by your calculations. They have their own métier, their own rhyme that is unaffected by the integers in your abacus.

INGRATIATING

There is a fable about two dogs — Barbos and Joujoutka. One day, Barbos notices his old acquaintance Joujoutka seated comfortably on a soft cushion, and wonders how come her life has changed so much since they met. Earlier, they both used to suffer hunger, but now she lives in comfort, while Barbos still suffers from hunger, neglect and cruel whipping from his master. He asks Joujoutka what she does for being treated so well. She answers, "I walk upon my hind legs (to please my master)."

Every organisation usually has one such Vile who makes life uncomfortable for everyone else by polluting the workplace in order to satisfy his economic and personal ends. By trying to rise through genuflection, he brings down the standards of executive behaviour. He tries to wriggle to the top without any talent other than his obsequiousness.

Such a Vile prefers to take the elevator to the top.

He understands if he submerges his ego to the power-that-be, rewards shall ensue. Watch him at work. The professional ingratiator undergoes a complete metamorphosis when the bosses show up. Almost magically, he manages to distance himself from his colleagues, and gives the impression that he'd only been talking with them to keep them away from disobedience and rebellion.

Often, such Viles flourish in environments where the boss is too full of himself. Sensing this, they may go to extreme lengths to feed the boss's vanity, by praising him openly and singing his song for him. Moreover, they justify their sycophancy by labelling it as a 'positive attitude' or by suggesting that it is an outcome of their undying admiration for their leader. They do not look at their reflections in the mirror and so never find out what caricatures they have become. They also do not care how they appear to others. There are broadly two Super Vile ingratiating strokes:

Stroke A – **Ingratiating through gratitude.** Vile convinces his master that his admiration for him stems from what his master has done for him in the past and is permanent. He differentiates himself from others by his eternal admiration and sincerity. Through this stroke, not only does he ingratiate the master, but qualifies for even bigger favours in the future.

Stroke B – **Unique taste-ingratiation.** Here the Super Vile chooses a trait in the master that is unique, but neither noteworthy nor important. He blows out of proportion his admiration for this trait. The master, unsure in the beginning as to how to react, looks askance but finally starts taking the bow to his applause. Super Vile thus ties himself to his master with a unique string of ingratiation, which cannot be cut by any of the other Viles. Also, his gullible colleagues may see him not so much

as a flatterer but a freak, with an unquenchable love for an uncommon trait.

Advice for the Ruler

- *We love flattery, even though we are not deceived by it, because it shows that we are of importance enough to be courted.*

 — Ralph Waldo Emerson

- Do not let the productive and dignified people lose their rewards to co-workers who are compliant and worshipful.

- Encourage the expression of independent opinions and display of courage of convictions rather than servility.

LYING

To be persuasive, we must be believable. To be believable, we must be credible. To be credible, we must be truthful.

— Edward R. Murrow

The purpose of a lie is usually to deceive, to protect oneself or get an undue favour. All lies are not bad. It is the purpose of the lie which ascertains whether it is good or bad. Here is an example of a good lie.

Richard Gere plays a millionaire in the movie *Pretty Woman*. He falls in love with a prostitute (Julia Roberts).

When accompanying her to a party, he is asked by a friend, "What does she do?" Gere replies, "Oh, she is in sales." Through this lie (a semi-truth is a lie too), he protects the reputation of his beloved.

Some habitual liars lie to enhance their status. Their purpose is not to harm anyone but to project themselves in a particular way. Usually, such people suffer from low self-esteem and end up

name-dropping. This name-dropping is not restricted just to dropping names of people they know or have met. It may include dropping names of the fine dining restaurants they have visited or places where they went vacationing.

Others lie to themselves. Here is one story that illustrates this case.

A man climbs a berry tree to pluck some fruit, but realises the berries are at the end of a branch that is difficult to reach. Silently, he promises to God that if he does reach those berries, he would offer an hour's wage as alms at the temple. He then makes good progress towards the berries and, when he is quite close, gets second thoughts. Perhaps, he promised too much for just a bunch of berries that was not very far from his grasp. He then feels, 'Why did I have to bring God in the matter at all? Perhaps a fraction of the amount promised as alms would do.' Just at that moment, distracted by his thought, he loses his grip and falls. Looking skyward, he says, "You can't even take a joke."

The strokes in malafide lying are:

Stroke A – **Add doses of verifiable truth to your lies.** Big lies, with some ring of truth to them, are gulped down more easily. A subtle variation of this stroke is to tell a truth that can be verified and attach it to the lie. The listener checks the former, finds it to be true and assumes the rest is also likewise true. But Vile takes care that even though it is a big lie, it is still kept short. Short lies, he knows, have less chance of discovery.

Stroke B – **Lying by majority.** Vile's confidantes utter the same lie. Endorsement by the majority makes the lie more believable.

Stroke C – **Alluding.** Here Vile just hints towards something obliquely that is not true, and since he has merely hinted, his

risk is covered. He can always retrace his steps in the event of a scrutiny. He often uses allusions to seed animosity among people around him.

Stroke D – **Lying by omission.** The crucial data is omitted. Naive introduces Vile to one of his influential friends and would like to be posted on the proceedings of their meetings. The first few times Vile meets this contact, he reports the details to Naive, but soon becomes evasive, ensuring that he omits the key points discussed. Social climbers often indulge in this type of lying.

Stroke E – **Emotional lies.** Vile gets extra emotional about the topic of discussion. His sudden, strong, emotional outbursts are a camouflage for his lie.

A monk visiting a fellow monk's house, while having lunch, finds a much-stained mat on the floor. He asks his host, "Do you sleep with any woman?" Enraged, the host bellows, "I am a celibate. How dare you ask me that question? Finish your lunch and get out of my house." Shouting thus and fuming, the host monk leaves the dining area and goes to the courtyard. The guest monk too leaves for his home a few minutes later. Next morning, the host monk discovers that one of his silver spoons is missing. Doubting the guest of the previous day, he sends him the following note, "I won't call you a thief, but if you find my missing silver spoon, please return it to me." He promptly receives a note in reply that says, "I won't call you a liar, but you would have found the spoon on your bed last night if you had slept on it."

Stroke F – **White lies.** When confronted with a situation where it is his word against that of another, Vile outrightly denies having said or committed a thing. It is for this reason that sometimes it is wise to carry a trusted one with you while negotiating a deal with Vile. Though it is a good precaution, it

may not be sufficient to nail him to the truth, because to deny something Vile can even make it appear as if he was misunderstood.

Stroke G – **Indirect lies.** In this case Vile does not lie directly to the person whose interest is at stake or the one he wishes to influence. Instead, he lies to a third party who is close to the one he wishes to lie to. He states the lie as though entrusting this third party with a secret, and hopes his lie would be systematically passed on to the person of interest.

Stroke H – **Lying out of jealousy.** Here Vile lies to bring down the achievements of another, because he feels incapable of emulating him. For example, he may make little of the other guy's riches by denouncing him as greedy. This act of lie stokes Vile's ego.

Advice for Naive
- You cannot believe everything you hear, even if you hear it twice.

Advice for Vile
- A lie may take care of the present, but it has no future.
- Be sincere instead of trying to fake sincerity. It takes the same amount of effort!

Advice for the Ruler
- *Don't see all that you see, and don't hear all that you hear.*
 — Irish proverb
- Lying can be done with words and also with silence. Credit poachers often lie through silence.
- If you feel someone is lying to you, look as though you believe him. This will encourage him to go on and on and in the end to betray himself. If a person conceals something, behave as if you do not believe him. This will lead him to tell the truth.

ANONYMOUS LETTER GAME

If the ruler takes those that the world commonly praises as being worthy and those that they condemn as being worthless, then the larger cliques will advance and the smaller will retreat. In this situation, groups of evil individuals will associate to obscure the worthy. Loyal subordinates will die even though innocent. And perverse subordinates will obtain rank and position through empty fame.

— Six Secret Teachings

This game is little known to the average employees. Some politicians and industrialists revealed this game to me. One minister lamented that he frequently received anonymous letters that were usually directed against some person. It was also difficult to guess as to who was the scribe. Most often, the letters were typed.

"Do these anonymous letters influence your opinion about the person who is the butt of the attack?" I asked.

"Usually, only for a moment," he replied, "unless the letter speaks adversely about the addressee. If that were so, it would be natural for the addressee to be disturbed."

It is this natural tendency to be prejudiced against someone who criticises you, which the ruler needs to learn to guard against.

Advice for the Ruler

• *If the General believes the slander, he will lose the hearts of the people.* — Huang Shih Kung I

SEXUAL HARASSMENT

If you play with cats, you will get scratched.

— Irish proverb

A London publisher took his mistress to Normandy, leaving his wife under the impression that he had been called away to Brussels on business. The sneaky pair spent a blissful week together in an old-world hotel, basked in the sun, wined, dined and loved in fine style. They returned home, convinced that their secret would never come to light.

A year later the publisher, perhaps with a pang of conscience, took his wife to a travel agent to arrange a holiday for just the two of them. Browsing through the brochures she came across one extolling Normandy as the place to unwind. The cover showed a happy, laughing couple leaning against a harbour wall with their arms around each other, unaware they were being photographed by the French Tourist Board. It was her erring husband and his mistress.

— Sue Black Hall

Dr Stephen Ward, a fashionable London osteopath and talented portrait artist, survived on the patronage of the rich and powerful of his time. Sir Winston Churchill and many leading politicians were among his patients. Ward also had an interest in young girls of humble origin, and groomed them into high-class prostitutes. "I like pretty girls," he was reported as saying, "I am sensitive to their needs and the stresses of modern living."

One such girl was Christine Keeler who Ward introduced into a world of the rich and famous, aristocratic, charming and powerful men, all eager to woo her. John Profumo, the British Secretary of State for War, whom Ward introduced to Keeler at a pool party at Cliveden, was among them. Profumo started soliciting Christine's services, but when the scandal (Profumo scandal) broke out, Profumo denied his affair with Keeler, and convinced the State, the House of Commons and even the Prime Minister, Harold Macmillan, that any suggestion of an affair with her was untrue. But Profumo's lie was subsequently caught and the press moved in for the kill.

In the fallout of the Profumo scandal, Ward was arrested on charges of knowingly living wholly or in part on the earning of prostitution. The trial exposed Ward and his social circle to the full glare of the media. Rumours began to spread of an international call-girl ring involving British and US politicians and celebrities. Ward finally committed suicide by taking an overdose of sleeping tablets on the last day of the trial. Profumo was forced to resign and the Conservative government lost the next election.

Vile wants to exploit the senior-subordinate relationship sexually. To achieve sexual gratification, the following strokes are tried:

Stroke A – **Eye contact.** Vile tries to make eye contact to make the woman weak, as he feels this is the first step to her heart. He may even try to undress the woman with his gaze. Her discomfort in such situations is not his concern at all.

Stroke B – **Late working.** Late hours promise more privacy, and Vile can move freely in his elements. There are less chances of her discouraging his advances, because they are not made publicly.

Stroke C – **Reward in return for sexual favour.** In this stroke, Vile offers some increment or promotion as a motivation for receiving sexual favours.

Stroke D – **If she doesn't take the bait, bend her.** He also schedules his itinerary, so as to be present where she is when her job requires touring. Again, away from the office, he gets more privacy to bare his fangs. If all fails, Vile makes her look inefficient, demeriting her merit.

Stroke E – **Playing pimp for superiors.** This is a Super Vile's stroke, wherein Vile debauches his senior with beautiful women. He then banks on the senior becoming depraved or on the fact that he shares his master's secret.

Advice for Naive/Vile/the Ruler
• Practise restraint. (*Read* the *Saint and Robber Story* on p. 125).

NEGATIVE RECOMMENDATION GAME

Some sink the ship forever while posing as benefactors.

In this game, the recommendation is made as though in all earnest, but the grounds for making the recommendation are deliberately kept not just weak, but such that they cripple the candidate's candidature. This game even ensures that in spite of having scuttled the case once and for all, Vile can still take the credit for having recommended the case. Vile knows that if he doesn't keep an arm around his victim's shoulder, how will he stab him in the back?

One lobbyist (minister-maker) was requested by his cousin (a member of the legislative assembly) to plead his case for the post of a minister. The lobbyist assured his cousin that he would indeed plead his case with the Chief Minister. He recommended the case to the Chief Minister saying if the MLA (his cousin) is given a ministerial birth, it would be very nice and that his cousin

would then also be able to return the money he had borrowed from the market.

He knew the Chief Minister was an honest man and would now never make his cousin a minister. He scuttled his cousin's candidature forever through a negative recommendation.

A very productive salesman wanted to be transferred to his hometown. A vacancy came up there and the senior management was ready to grant him his wish. His immediate superior (the area manager), however, did not want this to happen. When he was consulted, he spoke thus, "He has been a good salesman. He indeed deserves to be transferred to his hometown. Moreover, once there, he can do more for his family. He can prove to be of some help to his brother in running his transport company and to his father in running his chemist shop." Of course, the transfer didn't take place.

Advice for Naive

- If the purpose is not sincere, it always boomerangs in the end.

Advice for Vile

- The best tranquilliser is a clear conscience.

Advice for the Ruler

- Always ask who benefits from the recommendation and use your own judgment.

- Just as there are three primary colours, there are three primary emotions: love, hate and jealousy.

MONEY-MAKING GAME

Money made through dishonest practices will not last long.

— Chinese proverb

For every man with money, there is another one scheming to relieve him of it. For every man with a trusting nature, there is another ready to make him a little wiser. By the time the gullible discovers that he has blundered, it is usually too late! The purpose of this game is simple: Make money on the side through suppliers of goods and services. The several strokes of this game are:

Stroke A – **Giving differential deadlines/guidelines.** Vile favours his partners by giving differential deadlines for quotes. In other words, the parties that Vile doesn't want in the fray are given near-impossible deadlines to quote their price. They are not given the information they need to put up their quote (such as organisational needs, guarantee period, rejection limits, etc.). The result is they cannot scan the market effectively or may get

disqualified from the contest because of a rule that they failed to follow as they were not informed about it.

Stroke B – **Approving monopolist items of favoured parties.** Those items, which could only be supplied by the favoured parties, are chosen, so that there can be no price benchmarking.

Stroke C – **Nitpicking problems with other parties.** This includes finding problems in their bills, jobs and other areas, and forcing his juniors not to entertain them.

Stroke D – **Asking for more goods than required, or accepting less goods than are billed.** In the first case, Vile's pro rata earnings go up. And in the second case, the amount due for those goods, that were ordered but not supplied, is pocketed.

Stroke E – **Psyching the juniors.** Here, the juniors are told that complaining to the higher authorities will not help them, as the latter are involved in the graft too. *The corrupt also often justify their actions to themselves by rationalising and assuming that the people at higher stations above them are also corrupt.*

Stroke F – **Sharing the loot.** If others are also making money on the side, Vile turns a blind eye.

Stroke G – **Grant favours to those who can ensure future security.** In this stroke, Vile doesn't look for immediate monetary gratification from the vendor. He uses his powers to oblige those who can oblige him later.

Advice for Naive

- Honesty is the first chapter in the book of wisdom. Honesty in little things is not a little thing.

- Safeguards against being cheated don't lie in the contracts, but in dealing with honest people.

Advice for Vile

- If you wish to do business with honest people, you must be honest yourself.

- Dishonesty is like a boomerang. Just when you think all is well, it hits you in the back of your head.

- Material success is far more satisfying when it comes without exploiting others, and from the love of what you're doing.

- A senior bureaucrat entered into many anonymous transactions (acquisitions made in other people's names) to hide his illicit wealth. When out of power, his friends deserted him and ran away with his property; he got a heart attack.

Advice for the Ruler

- People are never sneaky in only one area of their life.

- *Do not shoot the Indians and let the chiefs who turn the other way, ignore the issues or who were too busy to see it, go free.*

— John F. Welch

- *A wise man does not make a goat his gardener.*

- *A man who will steal for me can steal from me too.*

NURTURING INCOMPETENCE AND FINDING SCAPEGOATS

Franklin D. Roosevelt was an honest and fair person. Yet, there were times in his political career when things went wrong. It was on such occasions that his secretary took things upon himself without complaining. For the larger good, Roosevelt allowed this. This arrangement also created an enduring bond between him and his secretary. The qualities such leaders seek in their candidates are malleability, likeability, flexibility, low intellect and, most of all, no desire or conviction to change things.

When Jim Wright was gaining his power as Speaker of the House, he appointed people for their personal loyalty rather than for their intellectual accomplishments. Even the finance division at General Motors established and maintained its power during the late 1950s by promoting people who were loyal and devoted rather than competent.

During the siege of a city Ts'ao Ts'ao, the mighty General

Han miscalculated the timing for supply of grain. The army had insufficient food, and the chief was ordered to reduce the rations. Ts'ao Ts'ao received information that the armymen were grumbling and complaining that while the General was feasting, they were starving. In order to avoid a mutiny, the General requested the chief to lend him his head to show to the troops, promising to look after his family, when he was no more. The head, when shown to the soldiers, prevented the mutiny.

The objective of this game is to protect oneself if anything goes wrong, and insulate oneself from any challenge. Vile falls back upon the incompetent or the innocent subordinate in case of a blunder. Usually, Vile tries to avoid keeping an incompetent guy who is dumb. He prefers keeping an intelligent/knowledgeable incompetent.

The strokes of the game are:

Stroke A – **Keep an incompetent colleague as immediate subordinate.** Loyalty is instilled in the incompetent colleague by letting him know that Vile is aware of his handicap and still bears up with him. Because of his incompetence and his gratitude for Vile, primarily the former, the subordinate can never challenge him.

Stroke B – **A friend is recruited as the hatchet man.** The dirty work, that every man in power has to do, can be assigned to him. If the plans go awry, he can be made a scapegoat. Also, when fights break out, such a person is often made the front man. In case of a trade off, Vile can easily sacrifice and replace him with an equally incompetent fellow. Kings, who often let their closest friends in the court take the fall for a mistake, often employed this trick. Of course, after this game, the friend is lost forever. But that doesn't concern Vile.

Advice for the Ruler

• If you hire mediocre people, they will hire mediocre people.

Advice for Vile

• The French elections of 1848 came down to a tie between Louis-Adolphe Theirs and General Eugene Cavignac. When Theirs realised his weak hold, he chose Louis Bonaparte, grandnephew of the great General Napoleon, whom he saw as an imbecile but whose name could get him elected. Theirs thought that Bonaparte could be used as his puppet and then pushed offstage. Napoleon was elected. Theirs could not foresee that the 'imbecile' was a man of great ambition who, three years after coming to power, dissolved the parliament and declared himself the emperor and ruled France for eighteen years, much to the horror of Theirs and his party.

JEOPARDISING ORGANISATIONAL INTEREST

Indulging oneself, while instructing others is contrary to natural order; rectifying yourself and transforming others accords with the Tao.

Brigadier General Jean Louis Jeanmaire epitomised everything the Swiss army could hope for in a top-ranking officer. He was fine, upstanding, honest and loyal to his country — the perfect patriot and soldier. People listened respectfully when he listed the many virtues of Switzerland and the evils of communism. By 1957, Jeanmaire had been made a full colonel and was becoming accepted in Switzerland's upper circles. His ideas were shattered when he was transferred to the civil defence force. A couple of years later, he became a Russian spy.

This is a game played by a resentful Vile. The resentment may be borne out of any injustice (real or imagined) done to him by his superiors. The issue could be suspicion, supersession, a

new boss, or an increment. He plays the game to vent his grievance.

Stroke A – **Shirking responsibility.** He openly starts shirking responsibility, poisoning his juniors, putting a spoke in the wheel or even sabotaging the operations of the organisation.

Stroke B – **Making somebody else press the trigger.** In doing so, he makes sure that the blame of the wrongdoings cannot be laid on his table. For this purpose, he makes others endorse his decisions and implements these wrong decisions through consensus.

Stroke C – **Leaking vital information to rivals.**

Stroke D – **Planning a coup with the aid of a rival.**

Advice for the Ruler

• Values need to be woven through rewards and punishments into the organisational fabric. Great results can thus be achieved with small forces.

• *A mass of a hundred thousand that does not follow orders is not as good as ten thousand men who fight. Ten thousand men who fight are not as good as hundred men who are truly aroused.*

— Wei Liao-Tzu, 2

NAIVE — HOW HE CAN RISE

DIGESTING SUCCESS AND HANDLING POWER

Success is more a function of consistent common sense than it is of genius.

— An Wang

Plenitude and prosperity make us lazy and inactive. When our power is secure we don't feel the need to act. This becomes a serious danger, especially for those who achieve success and power at an early age. Playwright Tennesse Williams, for instance, found himself skyrocketed from obscurity to fame by the success of his play, *The Glass Menagerie*. The play was a smash-hit in Chicago, burst its way to Broadway, and won the New York Drama Critics' Circle Award for best play of the season.

"The sort of life which I had previous to this popular success," he later wrote, "was one that required endurance, a life of clawing and scratching, but it was a good life because it was that sort of life for which the human organism is created. I was not aware of

how much vital energy had gone into this struggle until the struggle was removed. I sat down and looked about me and was suddenly very depressed."

With no fresh challenges in sight, with no more mountains to scale, Williams eventually had a nervous breakdown. This, in fact, proved godd for him. He was in the valley once again. He could see new mountain slopes, which beckoned and challenged him to climb again. He started his journey again and produced his most famous work, A *Streetcar Named Desire*.

Russian novelist, journalist and short-story writer Fyodor Dostoyevsky's psychological penetration into the human soul profoundly influenced the 20th-century novels. He presented characters with contrasting views about freedom of choice, socialism, atheism, good and evil. But his central obsession was God, whom his characters constantly searched through painful errors and humiliations. Interestingly, whenever he wrote a successful novel, Fyodor would feel the financial security he had gained which made the act of creation unnecessary. He would then go to the casino and gamble away his entire wealth so he could be reduced to poverty once more and be able to write again.

Not just monetary success, but even power has a curious way of climbing. It goes to the head, makes those around you restless and unhappy and leaves you delusory.

A journalist was once visiting a town to meet the Mayor, but before the meeting, he went to a few people and enquired from them about him. The following were some of the responses he received.

The petrol pump attendant said the Mayor was a bum, a

housewife remarked he was lowlife, while the priest of the town thought the man was a scoundrel. Everyone, the journalist spoke to, held a poor opinion of the Mayor. So, while chatting with the Mayor, the journalist finally asked him, "How much do they pay you here?"

"Oh, nothing. I took this job just for the honour of it," the Mayor replied. He had no clue that contempt lurked behind the deferential exterior of people towards him.

So when power gets to one's head, one is greatly inclined to become insensitive and vain, and it is very important to guard oneself against this vanity, lest we turn into caricatures of ourselves.

Also, if the past successes are not quickly digested, the psyche begins to disfigure. It is imperative, therefore, to quickly digest the power one achieves. There are several ways of doing it. First every achievement should be viewed as a milestone, not as a mountain peak. If past glories begin to weigh heavier than your future dreams, take it as a warning that decay is setting in. Enjoy the adulation, respect and comfort that success brings, but don't become complacent. Remember, what made these pleasures possible and sustained the efforts that led you till this point, as the thrill of life lies in the journey; destinations are mere parking spaces to stretch your limbs and refuel. Action is life, lassitude is death. So when you reach one landmark, relax and relish the experience, but do not abandon the effort required to travel further. Set the bar higher.

Or look at people whose achievements are bigger than yours. Seeing your place in the larger scheme of things also helps change one's perspective as this story illustrates.

Socrates was sitting in his school with several of his students, when an extremely rich and famous man of Athens entered the hall to meet him. Socrates didn't notice his arrival and continued his discussions with his students. The man felt affronted but still decided to wait a while. But with every passing minute, his anger mounted. After about half an hour of waiting, he suddenly shouted at Socrates, "You don't know who I am?"

Socrates looked at his visitor and said, "Let us decide that too." He called for a world map and asked this man to point out where was Athens in the map. After careful scrutiny, the man pointed to a little speck. Socrates then asked him to point out on the map where his estate was, where his palace was and so on. Realising those possessions that he was so proud of were specks within specks in the larger scheme of things, the man was at a loss and came to terms with his own insignificance. The lesson was completed. Socrates folded the map and handed it over to him as a reminder of his humble status in the world.

Another tip for digesting power is to develop your feminine polarity. Man is aggressive by nature; woman is compassionate. The Bible states, God completed the creation of the world in six days, yet every subsequent day, he kept refining his creations until he created man. Even then he was not satisfied. So he took a bone from man's rib and created a woman — a more refined version of man. In fact, a man becomes complete and capable of great achievements only when he recognises his own feminine polarity — his warm, giving and kind self.

For instance, Amitabh Bachchan, the Indian film superstar, gets up early in the morning at 6 and runs a packed schedule till late in the night. Even after such a hectic daily schedule, before going to bed, he tends to his old bed-ridden mother, sits by her side and tells her all that transpired during the day.

Once in a blue moon, his weary, bed-ridden mother speaks a sentence or two to him. In these couple of sentences, Bachchan finds his reward. How many of us spend time with our aging parents? How many of us feel kindly towards them? I feel it is this rare and highly developed feminine polarity of compassion which has helped Bachchan digest his riches and fame. This excellent digestion creates space for more riches and fame. In his career, he has scaled peak after peak. In fact, it won't be an exaggeration to say that he is the undisputed monarch of the Indian film industry. He was even voted the star of the millennium by BBC online readers.

Understanding the principles of Tao, the hidden order that governs the universe, is the key to handling power. The principle of cosmic justice is based on the maxim that a person reaps what he sows. The doctrine of karma and belief in divine retribution are different expressions of a common principle that the world is governed by the principle of justice. Justice (balance) is inherent in the fabric of the cosmos.

Thus, when giddy with power we lose touch with our inner rhythm, or the Tao, and behave recklessly or cruelly, retribution does come. It perhaps does not come from some God sitting in the heavens, but from within us when, due to our physical and mental imbalance, we are no longer available to our possibilities.

The recognition of the role of luck in our achievements also helps keep humility alive in us. It is indeed not just one's prowess, but also providence that leads him to a position of power. This realisation subdues the ego.

Lastly, we need to learn to love our people and be kind to them. Love is an enzyme that digests power, and compassion is the best antidote against power's corrupting influence.

CATCHING SIGNALS

To see things in the seed, that is genius.

— Lao-Tzu

Very few men can think and feel beyond the present. One must pay attention to an inner intimation of the future not depending upon fortune-tellers, but through simple observation and awareness.

To fight the Viles of the world, this ability to understand signals is the key, and it needs to be honed. People can't but give signals. For instance, if a man is not considerate to others in small affairs and seeks only his advantage or he grabs another's due, he clearly reveals himself as unjust. A lot can thus be inferred about the character, mental make-up and disposition of a person by observing his words, behaviour and actions.

The wise can catch signals, which are not perceptible to others.

An Iranian merchant captures a bird in an Indian jungle, takes it back to his country and prisons it. When he is visiting India next, he asks the bird if he could bring something for it. The bird asks for its freedom, but the merchant refuses. The bird then asks the merchant to announce its captivity in its jungle-home in India. The merchant agrees to this. He goes back to the same jungle and while he's announcing his bird's captivity, another bird in the wild just falls down senseless to the ground. The merchant feels sad for the death of the bird. On returning home, he narrates this incident to his own bird. The caged bird catches the signal sent by its relative and falls dead on the bottom of the cage. The merchant thinks that the news of its friend's demise has led to his bird's death. He opens the cage, picks the bird up and puts it on the windowsill. The bird suddenly revives and flies away.

The bird could escape as it caught the signal — of how to behave to free itself — that was sent to it by its friend. It could thus beat her captor and win freedom.

Usually, it is a man's talk that reveals him. His speech, to the perceptive ear, is a mirror to his mind. Look for what he laughs on and how he behaves in trivial matters. Give particular notice when he changes a topic. With practice, you will be able to construct the bridge between one topic and the other. Once you can do that, you can practically read his thoughts.

Not only do men emanate signals, situations do so too. If a man is wise, he will not embark on any journey without keeping in mind the consequences.

There is a fable about two frogs that dwelt in a pool. They left their dwelling when the water dried up, and as they were searching for another home, they came across a deep well with lots of water.

The first frog suggested that they descend into the well for food and shelter, but the other frog, who was farsighted, advised his friend not to go into the well, because once there, they would not be able to get out if the well dried up. Likewise, one must always pay attention to the future consequences of present actions.

The wise take signals from almost anything. Once a king met a Sufi who proclaimed — he would give good advice for hundred dinars. When the requested amount was given to him, the Sufi advised the king never to begin anything without thinking about the consequences. Everyone laughed at this advice, but the king kept it in his mind and got the advice engraved in gold on the walls of his palace, and even on his silver utensils. Soon after, a plotter bribed the royal surgeon to kill the king by thrusting a poisoned lancet into the king's arm. When the silver basin was brought to receive the blood, the surgeon saw the engraved words of the Sufi on it, and realised that he may unknowingly become the plotter's next victim. He trembled at this thought, and on being questioned by the king, confessed the truth. The plotter was brought to justice. The king sent for all the people who had laughed at the Sufi's advice earlier and asked them if they would still laugh at the dervish.

When you have the same undesirable experience again, see it as a signal the universe is trying to teach you something and will do so, till you learn. It is also important to distinguish a signal from a false alarm or superstition, or else you will start reading signs when there aren't any.

In the movie *Troy*, the defending king intuitively reads a sign as a good omen, and trusting his intuition, gets ready for war, makes an attack and wins. When the enemy is getting ready to retreat and sail home the next morning, the king's ritualistic

priest advises him about another good omen. The king, superstitiously believing the advice, because it was given by the priest, re-attacks the enemy who was hoping to reunite with its families the next day. Pushed to the wall, the enemy fights back and crushes Troy. The ability to catch signals is indeed a gift of the universe, but the greater gift is that of wisdom. When you are not sure what the signal is in a given situation or when your intuition is mute, go along with wisdom.

Advice for Naive/the Ruler

• *It is easier to exclude harmful passions than to rule them; to deny them admittance than to control them after they have been admitted.*

— Lucius Annaeus Seneca

HANDLING JEALOUSY

First they ignore you, then they ridicule you, then they fight you and then you win.

— Mahatma Gandhi

Nicholas Fouquet, Finance Minister to Louis XIV, was a well-connected and sophisticated individual. According to one historian, Fouquet was an acknowledged leader of the intelligent society, a discerning patron of artists, a lover of fine buildings and women, and had an ever-increasing, ostentatious wealth. To please his young king, Nicholas threw a party in the year 1961, to which he invited the nobility and great minds from all over Europe. The event was a grand fete for six thousand "friends", including the king himself and his court. The guests were treated sumptuously. Party favours included 'diamond tiaras and saddle-horses'; the grounds were dotted by thousand orange trees, and the table settings were made of gold. Nicholas built an outdoor

amphitheatre of silver fir to house the spectacular entertainments, and fireworks lit up the sky each night during the week-long event. Although much honour was extended to the king, he was furious, and in less than two months after attending the eye-popping celebration, arrested Fouquet and bustled him off to the Bastille for life imprisonment. Louis XIV was an arrogant man, and his vanity was hurt by the fact that his friends and subjects were more charmed by Fouquet than by him. Out of sheer jealousy, he silenced Nicholas Fouquet forever.

Some masters become insecure because of the victories of their Generals. Philip of Macedonia assumed the throne after promptly overthrowing his infant nephew-king. On many occasions, he demoted his Generals immediately after great victories. Philip was troubled by the thought that such men might become rivals, instead of underlings in the future.

Vain and reckless display of one's victories should also be avoided. In fourth century BC, a captain in a Chinese battle brought back several enemy heads. "A talented officer, but a disobedient one," remarked the General and ordered that the captain be beheaded.

Never underestimate jealousy. Face it. Even your best well-wishers perhaps do not want you to do better than them. Few men have the strength to honour a friend's success without envy. The green-eyed monster can show up in unexpected ways in different situations.

A hospital room had two beds occupied by two seriously ill bed-ridden patients. They were good company for each other. The first patient used to tell the second one how beautiful the world looked from his window — how green the grass was, how beautiful the lake was and how merry the children were — a

view that the second patient wasn't able to share, as his bed was in the other corner of the room. He repeatedly reminded the second patient what a pleasure it was to look out of the window. The second patient got jealous as he could not enjoy the beauty of the outer world, and his desire for the first patient's bed grew. One night the first patient went into a bout of physical agony, coughing vociferously, so much so that he was not even able to ring the hospital alarm next to his bed. The second patient, who was witnessing the entire episode, could have easily raised an alarm but didn't. He was executing his plan. That night the first patient died. Next morning, the second patient requested the doctor to transfer him to the now vacant bed of the first patient. The doctor did so.

Happily, the second patient was wheeled on to his new bed and eagerly looked out of the window to see how beautiful the world was. Voila! There was no park, no lake, no children. Instead, there stood a dull, drab wall.

This story gives us two key lessons. We learn from the first patient that when you brag and inadvertently make people jealous of you, you end up digging your own grave. From the second patient we learn that wanting what others have may leave you worse off, as the second patient even lost the company he had.

Jealousy is a natural feeling. It is normal to be jealous. But there are two kinds of jealousies. The white jealousy, which inspires us to emulate the achievements of others, imbibe their values and improve ourselves. This is the constructive form of jealousy, which has been the driving force for most industrious and creative individuals who have been responsible for the advance of any culture. The other form of jealousy is the black jealousy that prompts us to be resentful of the achievements of others and embark on a hate trail against them only because

they have achieved something recognisably more useful than we have. It is this kind of jealousy that is negative and counter-productive.

When one is consumed with black jealousy he reacts violently to the achievements of the successful. The thought of the other man's success so consumes him that it affects his abilities to achieve. Instead of growing, he wastes his energies in retarding others. In this case, his preoccupation with the other man's success stunts him.

Then again, you not only need to stop yourself from being jealous of others, you also need to steer clear of those who are jealous of you. So long as the jealous don't come in your way, all's well. But at times they do float rumours, play down your achievements or even create hurdles in your path.

Then what should you do?

Seek their blessings. Let them feel secure by clarifying that you are not trespassing into their terrain and there's lots of space for everyone. If this doesn't work, ignore their efforts at discrediting you. And remember, your identity becomes stronger through opposition. Hitler did more to establish the strong identity that Jews have today than any one else by opposing them fiercely. He (unknowingly) crystallised their identity and, in fact, he can be credited with the creation of Israel.

When Hillary Clinton was the First Lady of Arkansas, she placed much critical focus on a rival Senator whose views she did not like, and highlighted his mistakes and drawbacks relentlessly during interviews. As a result, he rose to national attention, though his work had been largely obscure before. Clinton 'created' him through her excessive attention. He became even more of a vicious and effective enemy of hers.

One of the methods, therefore, to handle the salvos of competitors is not to react. It is better to build on your strength than go on a revenge-taking spree against them. Revenge will occupy your time, dilute your power and increase your stress. To be able to handle jealousy, it is important to know what steps would the jealous employ to discredit you or your idea. First, the idea is ignored. If it dies of neglect, fine. If it doesn't, it is criticised. If it even stands the test of criticism, then the Viles do not have any alternative; they have to accept it. When the idea is ignored, don't quit. When it is criticised, don't react and your creation will get its due place in the sun. Also, don't be instrumental in breeding jealousy by bragging about your riches or lifestyle among the less endowed. In fact, highlight the problems that you face in front of the jealous to reduce their jealousy.

Sir Francis Bacon, the philosopher who held many positions of power, thought that if the powerful people seek pity for themselves for taking the heavy load of responsibilities and sacrifices in public interest, no one would envy them. They should point out their troubles to win moral support from those surrounding them and share a part of their good fortune with others.

A student and a teacher are witnessing a football game. The student asks, "The poor ball gets kicked so badly. Who is at fault, the players or the ball?"

The teacher answers, "The ball. If it were not so full of air it would never get kicked." So be modest, as modesty will reduce the jealous vibes you attract.

Also, shun arrogance. Someone has rightly said that success brings arrogance and arrogance brings failure. Not only does the arrogant man lose his friends and advisors, he also stops receiving feedback on areas that need improvement. Practising what has

been proposed above will help you control jealousy to a great extent, but if you are enormously successful, you may not be able to uproot it completely. Then you can take comfort in the thought that if you worry about the bees, you will never get the honey. And simply go on doing your work.

Advice for Naive

- Envy is the price you pay for fame. It is only the tree loaded with fruit that people throw stones at. Let envy inspire you to work harder for what you want.
- Behold the turtle that makes progress only when he sticks his neck out.
- Keep away from those who try to belittle your ambitions.

Advice for Vile

- Do not discuss your success with those who are less successful.
- Envy is the enemy of happiness. You can't throw mud without getting a little on yourself.
- Use jealousy to fuel your life engine.

Advice for the Ruler

- The commonest way in which the unthinking envious minimise achievement is by attributing it to a stroke of luck akin to winning of lottery ticket.
- The failure of those who attempt extraordinary accomplishments is much more public. But success requires the courage to risk disapproval.
- To persevere in anything exceptional requires an inner strength and unshakeable conviction that you are right.

HOW NOT TO MAKE ENEMIES

Wrongs are forgiven, but contempt never is. Our pride remembers it forever.

Steve Jobs, the Chairman of Apple Computer which he co-founded in 1976, was a technical visionary. But he was forced to resign because of his arrogance and unwillingness to cultivate support within the firm, particularly among the board of directors.

The problem often is our ego, and unless we sacrifice a bit of it, it is difficult to build coalitions. It is indeed wiser to be polite and considerate than to be rude and rough, as rudeness only builds enemies. It is as foolish as setting one's own house on fire. A sensible man will always be polite, as politeness makes people pliable and obliging. Avoid arrogance and don't forget your manners. Remember, rudeness is a weak imitation of strength.

Powerful people also understand that often one's ego gets in the way of winning supporters.

If something is to be accomplished, one must overcome one's ego. Timely control over one's ego means greater power and resources in future. Sometimes it is important to fight, to be difficult, to make rivals pay for getting their way instead of doing what you want done. At other times, it is important to build alliances and a network of friendship by getting along.

Frank Stanton, the distinguished broadcast executive known for the leadership he brought to CBS during his 25-year presidency from 1946-71, was more than just a corporate president. He acquired the reputation of an unofficial spokesperson for the broadcasting industry. His opinions were routinely sought, his speeches repeatedly quoted, and his testimony before Congress was recognised as a major part of any debate.

As President of CBS, Stanton managed his relationship well with other senior executives, by giving them generous incentives, their private dining rooms and seats on the CBS board to enhance their prestige. During a union strike, Stanton supplied the picketers with coffee and, after the strike was over, time cheques were hand-delivered to the executives who had replaced the striking workers. Loyal gratitude was his because he improved the prestige of others in the organisation. While Stanton concentrated on organisational and policy questions, he left areas such as entertainment programming, and discovering and nurturing of talent to the Chairman, William S. Paley. Though Stanton and Paley had little in common, and Stanton was only seven years younger to Paley, he managed Paley well by showing unwavering respect to Paley in the presence of subordinates.

Avoid arguments and try to win through actions. This is possible if you are convinced that you are right and creative enough to prove it — without arguing.

In 1502, Piero Soderini, the Mayor of Florence, commissioned Michelangelo to do a grand sculpture for him. Weeks later, when Michelangelo was giving the final touches to the sculpture, Soderini entered the studio and told him that, though the statue was magnificent, the nose was too big. Michelangelo went up the scaffold and asked Soderini to follow him; he knew that Soderini had been standing just below the statue and thus did not have the right perspective. Taking a chisel in his left hand with a little marble dust, Michelangelo began to work with his chisel, letting a little dust fall now and then, but not touching the nose. Then he said, "Look at it now."

"It pleases me better," said Soderini, "you have given it life."

So Michelangelo came down pitying those who make a show of understanding matters about which they really know nothing. He did not offend Soderini. He just made him change his perspective without saying that he was ignorant.

A heckler once interrupted Nikita Khruschev in a speech, in which Khruschev was denouncing the crimes of Stalin. "You were Stalin's colleague. Why did you not stop him?" When Khruschev yelled out as to who had asked this question, no one moved in the crowd and there was pin-drop silence. After a few seconds, Khruschev said, "Now you know why I didn't stop Stalin." Instead of saying that speaking in Stalin's presence meant death, he made everyone realise what it was to actually face Stalin. The demonstration was sufficient and no argument was necessary. The moral of the story is to win by action, not by argument.

We should never assume the person being dealt with is weaker than us. If we want to turn people down, it is best to do it politely and respectfully, even if their proposal is ridiculous. When you are at cross-purposes with someone, consider all options.

Force is not usually the best option even if you are much more powerful than your opponent, because you can make him genuflect with a brute show of force but you can't make him forget the humiliation of his defeat. Its memories will come to haunt him and brew resentment in him. He will dream of revenge, or at least gloat when you fall.

A dear friend of mine shared with me an incident from his childhood when he was just eleven-years old. Every few months during his holidays, he used to visit his uncle's home in Kolkata. On one such holiday, he was passing a big bungalow and saw a branch of bougainvillea stooping over its boundary wall. He jumped and plucked a few of its colorful flowers. Suddenly from inside the house a middle-aged lady appeared, caught him and slapped him. So angry she was with his offence that in spite of his apologising, pleading, promising that he would never do something like that again, she did not let him go. She dragged him into the house and locked him in a dark storeroom in the basement. In the evening, the master of the house returned and realised the punishment far exceeded the little child's offence and quickly set him free.

Whenever my friend visited Kolkata thereafter, he would pass the house, look furtively around him and if no one was watching, throw a stone at the windowpanes. In three years, this boy broke 24 windowpanes of that house, and the family would have wondered who hated them so much. If they chance to read this book, they will know. Another point to note here is how the good act of the man (swift decision to set him free) never registered with my friend, who only remembered the old woman's wrath.

When angry, don't talk. At first, the anger may strike fear

and terror, but eventually embarrassment, uneasiness and resentment follow. Tantrums do not inspire loyalty. They only create doubts and uneasiness about your power. They herald a fall. When spiteful, don't talk; don't be vain. When vain, don't talk. In short, keep your trap shut!

Before speaking negatively about anybody, imagine the person being present there. According to Albert Einstein, the German-born American physicist, if A equals success, then the formula is $A = X + Y + Z$, with X being work, Y play, and Z keeping your mouth shut. Remember, every question does not invite response, and silence is never put on trial.

One keen aspirant for the post of a CEO in a large company made it to the last lap. The owner handed him the letter of appointment, saying, "I look forward to a long association with you." The would-be CEO replied, "Your offer is fabulous. But no one knows what the future holds, so don't blame me if tomorrow someone else lures me with a better offer." The owner promptly withdrew his hand along with the letter of appointment, and the sky fell on the aspirant's head. He didn't just put his foot in his mouth; he opened his mouth and a foot fell out.

Contrast this shooting from the mouth with the following example:

Down on his luck, screenwriter Michael Arlen went to New York in 1944. To drown his sorrows, he paid a visit to the famous restaurant '21'. In the lobby, he ran into (movie producer) Sam Goldwyn, who offered the somewhat impractical advice that Arlen should buy racehorses.

At the bar, Arlen met Louis B. Mayer, an old acquaintance, who asked him what his plans were for the future. "I was just talking to Sam Goldwyn..." began Arlen.

"How much did he offer you?" interrupted Mayer.

"Not enough," Arlen replied evasively.

"Would you take fifteen thousand for thirty weeks?" asked Mayer.

"Yes," said Arlen, without any hesitation this time.

— Clifton Fadiman

Above all, refrain from indulging in gossip, rumours or idle speculation as their fallouts can sprinkle on you. Don't fight another man's fight. Remember, Sun-tzu's advice: "If you are not in danger, don't fight." Stay neutral if both the parties are roguish.

Don't rush to the support of others unless they are dear and proven friends. You will not be respected as your help is easily obtained. Keep aloof. Aloofness is powerful. Don't burn your boats on someone else's advice. You may need it to get back.

Keep yourself free of commitments and obligations, as they are the leaks in your power — traps that enslave you to others. Avoid taking unnecessary obligations. Remember, something may be offered to you for taking much more. In short, be tactful. Be careful in sharing your secrets, particularly on what you think of your enemies, with anyone including your most near and dear. You are naturally trained to protect yourself from your enemies but not from your friends.

If you happen to have wronged someone, feel his hurt and apologise sincerely and graciously. It is important to wipe out the guilt and enmity from your heart, because one eventually begins to hate those he has hurt. The apology should be heartfelt. A stiff apology is a second insult. Avoid being harsh while announcing that you have been right and the other wrong, because besides creating needless enemies, you could very well be wrong the next time. Also, it is very important to be gracious in winning, as

the loser will eventually forget that you defeated him but will never forget how you treated him after his defeat.

Finally, don't expect people to be grateful. Gratitude is often a sham and is usually expressed only to entitle oneself for future favours.

Also, if your opponent knows he can humiliate you but not destroy you, then he has no power over you. He will stop trying to hurt you. One must not be deterred by small upsets; rather define the battle in terms of long-range goals. Then no single episode is a defeat. Express to your opponent your faith in his inability to persist in harming you. Ultimately, the enemy will side with you, if for no other reason, then for the fact that you've shown him that there is a winner in you, and that in your winning, he wins his own share of power by acquiring a greater reward or grander identity.

Advice for Naive

• *Some people approach every problem with an open mouth.*

— Adlai E. Stevenson

• One doesn't make many mistakes with his mouth shut.

• Let the refining of your own life keep you so busy that you have little time to criticise others.

• It is even more damaging to say foolish things than to do them.

• When someone lures you with the prospect of inordinate profit, remember to carefully assess the potential harm.

Advice for Vile

• Pride is at the bottom of most mistakes. And is the seed of many an enmity.

CONTROLLING ENEMIES

*Expecting the world to treat you fairly because you are a good
person is a little like expecting the bull not to attack you because
you are a vegetarian.*

— Dennis Wholey

In spite of all your endeavours not to make enemies, you tend to
have some, which is not so bad a situation. Without enemies, we
grow lazy. An enemy at our heels sharpens our wits and keeps us
alert. It is sometimes better to use enemies as enemies rather
than trying to transform them into friends or allies. The idea is
not to look out for enemies but make the most of those you have.
You cannot change your enemies. You can only control them.

In 1937, the Japanese invaded China, interrupting the civil
war between Mao's Communists and the nationalists. Some
Communist leaders advised Mao to let the nationalists fight the
Japanese. Mao disagreed, and felt the Japanese could not possibly

defeat a country such as China. In their fight against the Japanese, the Communist army would acquire training to reopen their struggle with the nationalists. The plan worked; the Japanese were defeated, and the Communist guerrillas perfected their hit-and-run tactics against the Japanese. This helped them win the civil war that soon broke out against the Kuomintang, after the war ended. The Communists also continued helping the peasant population wherever they could, thus spreading the word of communism. As a result, the Japanese 'Three All Campaign' in 1941, designed to turn the peasants against the Communists, proved a total failure. By August 1945, the Communists controlled far more of China than they had done in 1937.

Contrast this with the case below where revenge rather than a higher purpose, such as evolution, was the reason to make enmity endure and how it proved to be self-defeating. Benazir Bhutto, former President of Pakistan, had a long apprenticeship to power, studying under her own kinsmen and the other leaders of Pakistan. She took the post of President apparently to avenge her father's assassination and fulfill his wishes. She made her enemies pay, by teaching them hard lessons. One wonders whether the revenge gave her anything solid to feel proud of, any sense of accomplishment to take pride in.

The period that gives the greatest gain in knowledge and experience is the most difficult period in one's life. We cannot grow strong without a worthy opponent. By giving us a difficult time, our enemy trains us to develop inner strength, determination and courage, and indeed becomes our best teacher by giving us the chance to hone our skills.

Sometimes you need to engage your enemy and win, while at other times, disengage and win him over.

Abraham Lincoln delivered a speech at the height of the American Civil War and referred to the southerners as fellow human beings who were in the wrong. An elderly lady chastised him for not calling them irreconcilable enemies who must be destroyed. "Why, madam," he replied, "Do I not destroy my enemies when I make them my friends?"

In dealing with your enemies, don't also be preoccupied with checking whether they are being fair or not. Maybe the deal you got wasn't just. But if you worry about making everything fair, you waste precious time and energy. Just make it clear that you are for peace, but be prepared for war.

A good guide can be of great help in your preparation for war. He can even help you convert your handicap into a great asset.

A boy's right arm is amputated in his childhood. When he turns 15, he wants to learn karate and win the championship. He goes to the karate master and requests him to enroll him in the class. The master agrees, but gives the boy only one trick to practice. The other boys, he can see, are learning a variety of other moves. When he asks his master why that is so, the master tells him to carry on with his practice and achieve perfection in that one trick. For almost one year, this boy continues his practice. On the day of the competition, he approaches the ring apprehensively because of his limited repertoire. But to his and others jaw-dropping surprise, he knocks out his first opponent, then the second, and then the third, till he hears a heartening applause and his name being announced as the champion.

With tears in his eyes, he falls at his master's feet, and asks him how he was able to succeed with his limited knowledge, while his opponents had two hands and knew a greater variety of tricks.

The master replies, "Knowing your handicap, I taught you only one trick, which you did well to master. This trick does have an antidote but to execute it your opponent needs your right arm, which, my boy, you don't have."

During dangerous moments, not only do powerful people seek guidance, they also make themselves more accessible, seek out old allies and make new ones. They exercise their social muscle. This exercise and practice makes them more adept and comfortable at social interactions. They acquire social grace.

Sometimes just showing the adversary, particularly if he is not equipotent, a glimpse of your power can forestall the war. If you get a gun home (a gun could be an influential contact or your ability to fight for your principles), get it in during the day. Your neighbours should know you have it. Your possession of a gun may be a deterrent for most to attack you. This display is important even more when you are powerful yet peaceful. You are showing the world a glimpse of your power, so that the Viles of the world lay off. This is like beating the grass to startle the snake.

A venomous snake in a village goes about spewing its venom, biting the village folk and children. One day, a learned Swami visits the village. When the villagers lament about the snake, the Swami decides to go and convince the snake to give up his wicked ways. The snake is so taken by the Swami's nobility that it promises to never bite the villagers again. A few months later, the Swami visits the village again. When he inquires about the snake, the villagers nonchalantly point towards a little cave. The Swami enters the cave and is horrified to see the plight of the snake. It is lying bruised, bleeding and scared. The Swami asks

the snake what led to his sorry state. The snake explains: "I took your advice and gave up my habit of biting. Gradually, everyone lost all fear of me. Children started nudging my tail with sticks, the adults followed suit with stones. Bruised and battered, I drew away from the village and now await my death in this cave."

The Swami then says sympathetically, "I advised you to stop biting. I did not advise you to stop hissing. So hiss on, my child, to keep your fear alive in people, or else their evil will kill you."

If all the wise attempts at peace fail, and the Viles continue their attack, deliver a befitting reply. Attack the adversary with whatever you have. If the adversary has a sword and you have a penknife, don't be apologetic about your lack of armament. Stick it on his throat. Remember, the sharks are only as big as you think. Don't lionise your rival. It is a common mistake, especially if he has defeated you in the past. In reality, you lionise him because it boosts your ego subtly, and helps build back some of your lost self-esteem, as you feel that the one you lost to was *really* stronger. But in doing so, you become even more fearful. Understand the subtle machinations of the ego. Don't try to conquer your fear. Just do what you have to do, in spite of your fear.

Always choose whose support you seek. Don't go to your enemy's enemies to try and curry their favour. You must keep the battle focused on your agenda, and on yours alone.

If Gandhi had accepted the support of the United States in his confrontation with the British overlords, he would have ruined his chances at a clean win. The issues he fought for would have become muddled. His battle for freedom would have shifted into a contest between British and American imperialism, and his own vision would have been defeated.

Having said that, it is sometimes imperative to return the bad with bad. The Rajputs (martial race of western India) lost their empire because of blind adherence to principles. They did not have the wisdom to know that there are exceptions to the rules. It is as useless to deal with dishonest people in an honest manner, as it is for the sheep to pass resolutions in favour of vegetarianism while the wolf remains of a different opinion.

Also, trying to reform your opponents is like trying to change the preference of pigs for muck. Their original nature will resurface, just as an elephant rolls in the mud after a bath. So you just can't rule out retaliation as an option. But retaliation should be resorted to only when it is not the first attack. The first attack could have been a mistake. When you are torpedoed twice, nail them. Nail them without warning, without threatening, for if you exaggerate your threat, the adversary may use his most potent weapon against you.

When retaliation is the only option, retaliate strongly, directly and ruthlessly. And add to the powers of good in the world. At such times, conflict is contact. It needs power; it builds power. Getting ready for war makes you tough. It reminds you of the qualities necessary for victory, i.e. prudent judgment, courage under pressure, commitment and solidarity with your comrades. Peace, on the other hand, increases your peril by making discipline less urgent. Therefore, war raises your consciousness; peace makes you sluggish. At such times, bear in mind that because the good suffer silently, evil triumphs and dignity doesn't always lie in silence. This feeling will add moral force to your assault.

Even then, the purpose of retaliation should not be revenge, but rather delivering a message to the rest of the world not to

take goodness for granted. The art of war is not for killing people, but for annihilating evil. It is a strategy to give life to many people by ending the evil of one person. When you aim for the kill, let it be for your future security and peace; not for a past grudge.

Finally, while engaged with the enemy, don't reveal all your cards. Always keep an ace with you. Don't just use it because you can. Don't hesitate to use it if you must.

Advice for Naive

- All problems become smaller if instead, of indulging in them, you confront them.
- *That they may have a little peace, even the best dogs are compelled to snarl occasionally.*

— William Feather

- Avoid talking to your enemies. If there is a veneer of cordiality cloaking your enmity, just restrict your interaction to exchange of pleasantries. If you talk too frequently, you might utter something that can be used against you.
- *The fly cannot be driven away by getting angry at it.*

— African proverb

- *A gentle hand may lead an elephant with a single hair.*

— Persian proverb

Advice for Vile

- If there is nothing to be gained, there is no point engaging in war.
- Hatred is like acid. It destroys the vessel that holds it.

HANDLING BULLIES

People don't want to be defeated. But they do want to be won over.

— *The Princessa: Machiavelli for Women*

"How do you know when you are going to die?" poet Naomi Shihab asked his mother.

She answered, "When you can no longer make a fist!"

It is indeed true. The one who establishes his awesomeness is the one who is willing to fight. When the General is able to implement the Tao to awesomeness, his commanders begin to fear him. When the commanders fear their General, the people begin to fear their commanders. When the people fear the commanders, the enemy fears the people. For this reason, those who would know the Tao of victory and defeat must first know about the balance of power.

Do boldly what you do at all, because lions only encircle the hesitant prey. When you demonstrate your willingness to compromise, negotiate or go on the defensive, you are usually pushed around without mercy. Others sense your weakness and make the most of it.

A foolish boy was throwing stones at a man. The man offered the boy a few francs at his good aim and pointed him towards another man who could pay more. The boy ran towards the second man, who was the Mayor of the town and pelted stones on him. He was caught by the Mayor's servants and beaten rotten red.

Sometimes it is better to persuade such pests to attack somebody else who can more than pay them back.

Machiavelli, who tried to examine history and power, came to the conclusion that power stems from fear. He taught the power of oppression and believed people to be childlike who should at best be ordered around; that one should not seek their love; that if they love you, it's a sign you've lost control and they now have the upper hand.

The problem with this kind of power is that you burn up the very sources of energy you are using. The people around you come to hate you and dream of revenge. Only love makes them do things in the long run. I once met a 65-year-old Vile, who was a much feared and powerful figure not only in his industry, but also across other industries. He was brute power personified.

This was what he had to say, "I learnt from Machiavelli that if you rule through love, the handle of the rule is in the hands of the ruled. They may choose to love you or not. If you rule through fear, the handle of the rule lies in your hands. This thought appealed to me. I didn't know then that Machiavelli

was a dismal failure in his own lifetime. I ruled through fear, crushed any independent thought under me and punished indiscriminately to prove my power. There was always a sword hanging on my adversary's head if he did not comply with my terms. People buckled under my machinations. I made followers, not friends. Today, these erstwhile followers occupy positions of power. I thought I had defeated them, and they had surrendered. They hadn't. They remembered what I had done to them and took revenge. My shortsighted approach proved to be my undoing. Even my children are paying for my faults."

An enemy who knows you can't be intimidated is not likely to intimidate you.

Once upon a time in China, there was one of the cleverest Generals who ever lived. The man's name was Chuko Liang, who had an enormous army of soldiers, hundreds of thousands of men, under his command. But his army was so big that it wouldn't fit in his city Yang Ping. So, his officers camped and trained for battle in a location that was three days march away.

One morning, Simma Yi, an old enemy of the kingdom of Wei secretly sent his army of 200,000 soldiers to attack him. They were only a day's march away from Chuko Liang's city when the news of the approaching enemy quickly spread throughout the city, and left the people terribly frightened. The danger was very real and Liang knew he had to keep his people calm and protect them. So he thought of a plan of action right away. Telling everyone to gather in the square, he stood calmly before them, and said, "I have expected this attack, and I have just the right plan for defeating the other army." Liang ordered all his soldiers to go into their houses and hide there. Meanwhile, he sat calmly in his chair outside the city gate with a boy fanning flies away.

Soon, in the distance, Simma Yi's army could be seen approaching. On coming closer, Simma Yi called his army to halt, as the city looked so normal and calm. "Ah, Chuko Liang is a very smart General," thought Simma Yi to himself. "I bet this is a trap. The army must be hidden inside the city. If I attack now I am sure to be defeated."

Yi thus ordered his whole army to retreat, and Liang defeated an army of 200,000 soldiers merely by looking calm.

The story of Ivar Kreuger tells us succinctly that those who live by the sword die by the sword. Swedish industrialist and "Match King" Ivar Kreuger was the world's most brilliant thief, forger, gambler and swindler. Although he supplied 65 per cent of the world's matches from his factories located in 34 countries, Kreuger's dream was 'to control every match produced on the face of the earth'. He bought out or crushed all competitors. A firm that dared to resist his offer had its supplies cut off, or its workers beaten up. He was seemingly invincible because of his ruthlessness till came the crash of 1929. The Wall Street crash of 1929 forced Kreuger into financial collapse and left him facing his enemies who were just waiting for such an opportunity. The relentless attack from his enemies who also exposed a forgery case did him in. Kreuger went to his Paris apartment and shot himself.

Such events have happened often in history. A leader moves recklessly and acquires power. On the way, because of his recklessness, he makes many enemies. Eventually, his enemies band together and bring about his demise. The reason is, the aggressive person has no self-control. He cannot see the consequences of his actions and ultimately his own energy is turned against him.

Success brings its own problems. One problem which success may bring is bullies. They want their *cut* or they can't stand anybody competing with them in status. So how to handle bullies? Actually, the first question is: How *not* to handle bullies?

A child is beaten up by a bully in his class. He comes home with a black eye. When his father learns the bully far out-muscled his son, he gives him a piece of cake and tells him to give it to the bully and make friends with him. The son does as told. But, the next day, he comes back with another black eye. When asked what went wrong this time, he replies, "The bully wants more cake."

So, appeasement is out. You can't win them by appeasing them. Most bullies mistake goodness for weakness. When we make ourselves a sheep, a wolf is always around. If they get away with something, they will strive to get more.

Rana Ratan Singh was the ruler of Chittor. His wife, Queen Padmini, was a very beautiful woman. Alauddin Khilji developed a desire to possess Chittor as well as Queen Padmini. He sent a proposal to Rana Ratan Singh. He proposed if he were allowed to see Padmini in the mirror, he would not attack Chittor. In order to prevent bloodshed in the land of Chittor and to avoid any confrontation, Rana agreed to the proposal and complied. His complacence and failure to realise Alauddin's evil intention was a grave mistake. Legend has it, that Alauddin, struck by Padmini's mesmerising beauty in the reflection, went back on his words, captured Rana and agreed to free him only if the Queen agreed to become his beloved.

So the more the bullies get away with, the more they want to get away with. The best way to tackle them is to sound eager to sort out the matter, but not compromise on the principal issue.

To stay firm inwardly and bend outwardly is the essence of this tactic. This way, you do not give your opponent a chance to get angry.

Use wit and charm, as did Voltaire, who was living in exile in London at a time when anti-French sentiment was at its peak. One day he found himself surrounded by an angry crowd yelling, "Hang him. Hang the Frenchman."

Voltaire stayed calm and addressed the mob saying, "Men of England, you wish to kill me because I am a Frenchman. Am I not punished enough for not being born an Englishman?"

The angry yelling changed into cheering and the crowd escorted him safely back to his home.

Give off inconsequential benefits. This will help them save face. Don't send them retreating with their tail between their legs, even if you can. Give them the dignity of retreat. A true winner is the one who doesn't make the enemy feel defeated. Yesterday's enemy could be tomorrow's friend for a bigger war. Donald G. Krause, in his book, *The Art of War for Executives*, says, "When a competitor has exhausted his resources, give him a way out. Let him retain his ability to earn a living. Do not attempt to destroy him. This may prove to be a costly way to victory."

Try 'besting', which is a tactic in which your winning does not leave the opponent hurt or robbed of dignity. Besting is a form of victory in which you overcome an antagonist in style, just as in a race and your victory motivates everybody. But make sure the bully knows that if you are harmed again, you will hit back, even if you have to wait a lifetime for your chance.

Persevere in your battle, but don't insist. There is a difference in persevering and insistence. Though persevering against an

enemy is a mark of determination, insistence is more like stubbornness that tries to dismantle the rhythm of the universe. It is not just difficult, but counter-productive too. Return to your battle once again, not out of stubbornness, but when you sense the weather is favourable and all considerations indicate it is time for an encounter.

Be forgiving. All bullies are not bad. Sometimes you may have inadvertently hurt a person's ego that turns him into a bully and arouses hunger within him to harass you. If the bully has just made an attempt that has not harmed you, don't seek revenge. Else you will create another force to fight against his phantom. Things that are at the same platform are inadequate for conquering each other. So rise higher.

Advice for Naive

- *Slow movements and frequent avoidance are the means by which you entice an enemy to trample you.*

 — Ralph D. Sawyer
- Those who hate you don't win unless you hate them, and then you corrode yourself.
- You must not fight too often with one enemy, or you will teach him your art of war.
- To be wronged is nothing, if you don't continue to remember it.

Advice for the Ruler

- *Authority comes from warfare, not from harmony among men. For this reason, if one must kill to give peace to the people, then killing is permissible.*

 — S. Suma Fa I
- When upright behaviour fails to deliver, resort to authority.

MASTERING THE ART OF TIMING AND ACQUIRING PATIENCE

Give wind and tide a chance to change.

— Richard E. Byrd

There is a time to move fiercely, and a time to stand still like a mountain — a time to act and a time to wait. One should be able to detect the right moment and sniff out the spirit of the times. The idea is to surf the tides of time rather than get rolled under them.

The difference between success and failure is often a matter of timing as this example illustrates.

Mr Shih had two sons: one loved learning, the other war. The first expounded his moral teachings at the admiring court of Ch'in and was made a tutor, while the second talked strategy at the bellicose court of Ch'u and was made a General. The impecunious Mr Meng, on hearing of these successes, sent his two sons to follow the example of the Shih boys. The first expounded his moral teachings at the court

of Ch'in, but the king of Ch'in said: "At present the states are quarrelling vehemently and every prince is busy arming his troops to the teeth. If I followed this prig's prattle, we would soon be annihilated." So he had the fellow castrated.

Meanwhile, the second brother displayed his military genius at the court of Wei. But the king of Wei said: "Mine is a weak state. If I rely on force instead of diplomacy, we would soon be wiped out. If, on the other hand, I let the fire-eater go, he will offer his services to another state and then we shall be in trouble."

So he had the fellow's feet cut off. Both the families did exactly the same thing, but one timed it right; the other wrong. Thus success depends not on ratiocination but on rhythm.

— Lieh Tzu

Prime Minister Atal Bihari Vajpayee's government in India was on a shaky wicket in 1997. The coalition partners were creating trouble, the Opposition was ruthless in its attack, the industry was not supportive, and the press was exposing weaknesses. An ordinary politician in such a scenario would have politicked or parleyed. Vajpayee, instead, concentrated on following up with the Pokhran (nuclear) project. In May 1998, India successfully carried out its nuclear explosions. A new wave of patriotism gripped the country. The media could not but concentrate on this noteworthy achievement. Vajpayee's detractors turned into his allies and his government consolidated its position like never before.

I remember reading this gripping novel, *The Bourne Identity*. The protagonist, Jason Bourne, is a CIA agent. He is beaten badly by the Mafia, assumed dead and thrown into the sea. His body gets washed ashore, and some fishermen notice a semblance

of life in him. They nurse him back to life, except for one thing — he has lost his memory. He is now plagued with just one nagging thought, "Who am I?" One day, on feeling a lump in his thigh, he makes an incision and finds a microfilm placed there.

He finds the number of a Swiss bank account on the microfilm. This microfilm, he thinks, will provide the missing link to his past. He proceeds to this Swiss bank, goes to the lobby, gives his account number to the teller and expresses his wish to make some transactions. Soon a bank officer comes to meet Bourne. He is taken to the top floor of the building by the elevator. The officer informs him, there are 7,500,000 francs ($5 million) in his account. Bourne makes some transfers and continues his conversation with the officer in the hope the latter, through his talks might provide some clue to his identity. But he finds that no information as to *who he is* is forthcoming from the bank officer.

Meanwhile, someone from the bank informs the Mafia about Bourne return to life and his presence in the building. The Mafia promptly dispatches a team of four to assassinate him. Two of them take position in the lobby and the other two go up to the top floor and wait for him at the reception area, next to the lift. The idea is to kill Bourne in the elevator while he is coming down.

Bourne completes his transactions. However, his question, "Who am I?" remains unanswered.

He boards the lift to go down to the lobby and the assassins also try to enter the lift with their guns drawn. Bourne dispatches one of them right out of the enclosure with a kick. And his scuffle ensues with the other as the lift descends. As the lift is about to approach the lobby, in a couple of lightning moves, Bourne snatches the assassin's gun from his hands.

Having grabbed the assassin's gun, he points it on his temple and asks a question. What do you think is his question?

Stop.

Think.

Answer.

Now read on.

Most people think his first question should be "Who am I?" A few others feel it should be "Who are you?" or "Who sent you?"

All these responses are wrong.

Bourne, with his gun on the assassin's temple, barks, "How many men are there in the lobby? And where are they?"

Why? Because he has gauged the priority of the moment. His priority has changed. Just a moment before it was to find out who he was. But now there is little point in his knowing who he is, if, after a couple of minutes, he is going to be killed. The right inquisition for the moment was one that would save his life. That's why, "How many men are there in the lobby?"

What is the source of this sense of timing? Well, it springs partly from intuition and partly from disciplined imagination. While intuitive ability is more or less innate, disciplined imagination can be honed through conscious effort and practice. Disciplined imagination means putting the past data and information together to project the present or future scenarios. Through disciplined imagination, one can improve one's sense of timing.

PREVENTING SUBORDINATES FROM MAKING MONEY

I have heard the story about an honest contractor. Painstakingly, he executed every project that came his way. Throughout his life, he never accepted any inducement nor engaged in any misdeed. Despite his hard work he stayed poor and was pilloried not only by his colleagues and associates but also by his family members for making them live a life of deprivation.

Till one day, an honest minister came to his house. The government had awarded a contract for building a bridge to a clique of dishonest contractors. The contractors and many corrupt government officials had made illicit money on the transaction, by using poor-quality material in the construction of the bridge. Soon after the inauguration, the bridge collapsed. This caused adverse publicity by the Press as well as dissent in the public.

The new contract had to be given. This contractor's honesty had by then become a part of folklore. The minister wanted him to undertake the job. He had come to him to award the contract.

The contractor accepted the offer and prospered.

- Screen all parties. Initiate their entry into the company yourself. This way their loyalties will be with you.
- Make it clear to those under you that if you notice anything shady, you'll crack the whip.
- Make sure the deadlines and terms given to all the parties invited to quote are the same.
- Forbid your juniors to accept any gifts of value from the suppliers and tell the latter they should abstain from gifting. They will be happy.
- Keep their interaction with the vendors limited to just what is essential.
- Reward honest employees. Pay them well.
- Keep your hands on the reins. Given loose control, temptations arise.

Advice for Naive

- In matters of style, swim with the current. In matters of principle, stand like a rock.
- If you don't stand for something, you'll fall for anything.
- Be bold, but honest. Assuredly, mighty powers will come to your aid.

Advice for Vile

- If you don't stand for something, you'll fall for anything (it is necessary also for Vile to know this).
- *The lame man, who keeps to the right, outstrips the runner who takes the wrong turn, Nay it is obvious that the more active and swift the latter is, the further he will go astray.*

— Francis Bacon

Advice for the Ruler

- *If trickling streams are not blocked, they will become great rivers.*

 — Six Secret Teachings

- *Only benevolence can attract people; however, if one is benevolent but not trustworthy, then he will vanquish himself. Treat men as men: be upright with the upright, employ appropriate language, and use fire only when it should be used.*

 — Ssu-ma Fa

- *If good and evil are treated alike, meritorious officers will grow weary.*

 — Huang Shil-Kung

- *If he were to get angry but does not, evil subordinates will arise. If he should execute but does not, great thieves will appear.*

 — Six Secret Teachings

- From a group of small, big and powerful thieves, punish the strongest, most powerful of them all. You can create fear and respect by executing the great.

- This punishment of the strong may itself deter the smaller thieves.

- *When punishment reaches the pinnacle and rewards penetrate the lowest, then your greatness is effected.*

 — Six Secret Teachings

USING SUBORDINATES WHO MAKE MONEY

Sometimes it so happens that in spite of knowing that someone has cheated you, you are unable to sack him or get rid of him immediately for one of the reasons given below:

- You don't have a replacement for him.
- You wish to reform and not incapacitate him.

In such a case, how do you ensure the organisation benefits from such an employee? The best way is to block his money-making avenues as well as give him an impression that you *perhaps* know what he's up to. This, in my experience, is a very effective tool and changes many. The reason this works is because by subtly creating an impression that you *may* know of his mischief, you have not directly confronted him with an accusation. You have not made him dig in his heels. You have left him with space to change.

Imagine, soon after you join a company, a colleague of yours

presents before you an expense statement in which you believe, he has inflated the taxi bills. What should you do? Best would be to let the bill lie on the table. When he inquires if you have approved his expense statement, say that you are going through it. After a few days, approve it but circle the dubious expenses that you think he has inflated. Do ensure that the cheque reaches him along with this encircled expense statement.

In most cases, the technique works. The subordinate changes his ways. It works better than direct confrontation, if it is a first offence. Direct confrontation would have made him justify this higher expense. Even in future, in this case, for example, he might actually hire a more expensive car for his commuting and then produce a true and large enough bill that nearly equals the overcharged amount of the past and thus attempt to prove his innocence in the past. So when you do not have proof or when proof is difficult to get, it is better to leave him doubting that you know.

PREVENTING SUPERIORS FROM MAKING MONEY

Just put your point forth on the prudence of expenditure. If it is absorbed, fine. If not, forget it. Next time, for another case, put forth your point again. If it is taken, fine. If not, forget it. And so on. Don't talk. Don't display your ego about honesty. It is natural to be honest. Don't try to paint yourself as the good guy because you are honest and paint your boss as the bad one because he is dishonest. In simple words, don't carry your honesty as a chip on your shoulders.

Here is a passage from *Stripped Steel* by N.K. Singh.

"*At least we can bribe Harjinder and get him to do what we like. This man Sharma is useless. Neither he takes money nor he allows anybody else,*" Ram reflected.

"*I realised that an honest man can also be a stumbling block and nuisance. Vested interest only thrives on dishonest men. If you inject a good man, either the system throws him out like an unwanted body or*

he remains like a thorn, with all its pain and infection. So remember, if you have to change the system, you need to be within it."

- Also, you never know whose mandate your dishonest superior enjoys.

- You may not even know how useful your superior may be to the organisation.

- In fact, sometimes the entrepreneur himself may be involved. He may be a party to the overpriced goods his company has bought and thus may be trying to escape the tax net. In such a case, if you are the messenger, you may get shot.

- Every time try to save the company money; if you fail, try again. You will start succeeding eventually. If you have to change the system, you need to be within it.

- It is sometimes advantageous to make the senior, who is making money, feel that you are a fool. Then you can inadvertently step on the pipe, which feeds him, till he asks you to step off. When he does so, you sheepishly step away only to step back on it, dumbly, at the next opportunity you get.

Advice for Vile/the Ruler

• *If the king plucks one apple from the public garden, the public will take away even the roots.*

— Persian saying

WHO NOT TO SEEK ADVICE FROM

A lion was chasing a chamois. He was about to catch it but the agile chamois jumped across a deep ravine. The lion stood disappointed. At that moment, a fox came and provoked the lion to jump across the chasm, exhorting his strength and skill. The gullible lion jumped with all his might but could not cross the chasm. He fell into the ravine and died. The clever fox went into the ravine and feasted himself on the lion's remains, for many weeks to come.

- Don't take advice from one who has his own axe to grind. He might give you advice that might only suit his interest.
- Don't take advice from a stereotype personality. For instance, don't ask a guy, who thinks aggression is a panacea to all ills, for counsel. Abraham Maslow has said, *"When the only tool you own is a hammer, every problem begins to resemble a nail."*

- Be careful about who you pick up as a guide, especially when you are in trouble. The guide chosen should be wise and balanced and should not be someone who would project his own frustrations on the case.

 I know of a woman, who was engaged in a battle with her employer. On the salary day, she was handed over an envelope, which she found only had the allowance that she used to get in cash but not the remaining salary. Coming from a well-off family, she could manage her expenses, but couldn't help her relations with her employer getting strained further, as she was thinking that he had withheld her salary. Till one day, when she had to use the cash from the envelope, she discovered the cheque was lying folded within.

- Don't take advice from people who are in such a mental frame. Else their paranoia may rub off on you and you may start sharpening the spoons in your kitchens into knives.

- Seek advice from a person who makes you think for yourself.

HOW TO GIVE ADVICE

- As far as possible, try to restrain yourself from giving unsolicited advice. Give advice only when you are asked for it. That alone is the ripe moment for advice.

- If you feel someone can do well with your advice, but has not asked you for it, you can put your advice as an anecdote in your conversation. Such advice is usually lapped up, as it is he, who has caught it from his routine conversation with you, rather than receiving it as a sermon from you.

- Also when you give advice, don't expect the other person to recognise it as the most brilliant suggestion ever. Just say it and move on.

- Resist the temptation of giving ex-post facto advice. When you give someone who has just had a fall the "I told you so" or "I knew this would happen" advice, he

feels you are sermonising, taking advantage of his vulnerability. This leads to bitter feelings.

Advice for the Ruler

• *Men should be taught as if you taught them not and things unknown propos'd as if things forgot.* — Pope

• *Someone who is about to admonish another must realise within himself for five qualities before doing so [that he may be able to say], thus: "In due season will I speak, not out of season. In truth I will speak, not in falsehood. Gently will I speak, not harshly. To his profit will I speak, not to his loss. With kindly intent will I speak, not in anger."* — Vinaya Pitaka

WHY GIVE TALENT ITS DUE

Andrew Johnson, Abraham Lincoln's successor as President of the USA, isolated Ulysses S. Grant, a troublesome member of the government. He then forced him out. This enraged Grant, who then laboured to build his base in the Republican Party and went on to become the next President.

It is better to give talent its space under you. Else it might create empires in the neighbourhood. I know of many talented people who were not given their due in their organisations. Frustrated, they left and established competing companies or political parties, which became a severe threat to their former organisations. The idea should be to give the talented their due. This way they stay in your family and to that extent are controllable. Moreover when they shine, the family also glows. They are like the rising tide that lifts all boats.

It is usually a matter of ego. Outstanding talent often is egoistic (*please note,* vice versa is not true). To accommodate such talent around you, you must have a very large heart and the ability to keep sharing the limelight and sometimes even going totally without it. If you can submerge your ego, such talent can become rocket fuel, which will propel itself as well as you (its benefactors) to success. If one can be such a leader, he would be in great demand. This kind of large-heartedness is found many a times in women, especially when they are dealing with men. If a man recognises his own feminine polarity, he too can give space to those around him.

WHAT IF VILE GIVES YOU THE DITCH

He that wrestles with us strengthens our nerves, and sharpens our skill. Our antagonist is our helper.

— Edmund Burke

He is the best sailor who can steer within fewest points of the wind, and exact a motive power out of the greatest obstacles.

— Henry David Thoreau

In spite of all your great judgement and your desire to avoid Vile, you'll still come across him, for the world is full of them and they play true to their nature. So how do you deal with them?

You may have heard the story about a gullible man who lived in a desert. One day, as he is taking two of his sheep for a walk, a thief cuts out the leash and steals one of his sheep. When the owner realises that one of his sheep is missing, he goes looking for it frantically. He comes across a man, crying next to a waterless, dry well, wailing for his bag of

dinars that he has dropped in this well. The wailer proposes to him, "If you get my bag of dinars out of the well, I'll give you one dinar." The first man thinks, "I have just lost a sheep, but now I'm in for a dinar." He goes into the dark well. The wailer turns out to be the same thief who had stolen his first sheep. He laughs at the man inside the well, bids adieu and disappears with the other sheep as well.

The man is pained for having being fooled twice. But he thinks that had it not been for the thief, he would have never known how deep the well had been dug. Though it is a desert area, the floor of the well is damp. He thinks if he digs just a little deeper he might hit the water. He digs a few inches and he hears the gurgle of a spring of water. He digs a few inches further and the water comes gushing out. By selling the water from this well, he becomes a millionaire. He commemorates this well to the thief and in his heart feels ever grateful to him.

An ex-pat, who operated in a turbulent market, once said, "Sometimes I am given the ditch. I believe in divine justice, and see it coming to pass. The guy, who ditches me, through some mysterious law of nature, suffers. But that doesn't make me happy because his loss does not compensate my losses. I am truly happy only when I make use of the miserable situation I am in and come out stronger than I would have been, had I not been ditched."

The moral of the story is even if someone gives you the ditch, you can come out as a winner if you are persistent enough to dig deep enough to unearth the opportunity and creative enough to spot and use it.

So, if someone chucks lemons at you, make some lemonade.

How can this be done?

First, you should not hate the person who attacks you. Hatred will blind you to the opportunities which his attack may bring forth. Understand his feelings, his insecurity. If you can, pray for him. Not for spiritual reasons. But because only when the poisonous haze of hatred disappears will you be able to spot the opportunity in the attack. Usually, the stronger the attack the greater the opportunity it provides. Also, have no ego about your morality. It is natural to be honest and moral. This is no great achievement. Men are made so. This will help you see the amoral in less critical light and your hatred will dissolve and your vision will clear. Once the attack comes, mull over the opportunities it could provide. Then, use your creativity to try and change its motion, which is currently against you, to your advantage.

When an attack comes, you must see how you can imaginatively use its energy to further your growth. This needs creativity and ingenuity.

- When someone throws a brick at you, the conventional option is to throw a brick back at him. The creative option is to keep the brick and build your castle with it.

- If someone drills a hole in the hull of your ship, the conventional option would be to drill a hole in the hull of his ship as you sink. However, the creative option is to become a submarine which is more powerful than a ship.

- If you master the art of using others' energies to fuel your growth, you will not view the moves of the envious as attacks. The good should make good of any adversity they come across, juice every problem for all it is worth, tap it till it has given the last nickel it holds.

I have numerous examples of people who have been catapulted to power by winds directed against them, which they utilised by adjusting their sails.

Kiran Bedi, a dynamic and dedicated police officer, was given a punishment posting by her seniors who were rattled by her achievements and by the public attention she was getting. She was given the lack-lustre position of Inspector General (prisons). Rather than sulk, she set about implementing prison reforms. She wrote a book on prison reforms, which became a bestseller. She won the Magsaysay Award for her contributions, emerging stronger than ever before. By adjusting her sails, she utilised the negative winds directed against her to further the speed of her boat.

Indira Gandhi, too, would never have touched the pinnacle of her success had it not been for the Syndicate. When she came to power, she was known as the *Goongi Gudia* (mute doll) within the Congress. In fact, she was selected to be the Prime Minister by the Syndicate because of her meekness. When the Syndicate (Kamraj and others) sensed that she had a mind of her own, they gunned for her. She ran for her life, learning the ropes on the track. Rough seas made her a great captain. Soon, she was crossing one milestone after another (nationalisation of banks, abolition of privy purses) while, in the process, neutralising the power of her detractors.

They taught her the tricks and she became an adept player at the same game. She metamorphosed from *Goongi Gudia* to *Saakshaat Chandi* (goddess of destruction).

Advice for Naive

- It is not how far you fall, but how high you bounce.
- It is not what happens to people that is important; it is what they do about it.

FINAL TALLY: WHO WILL WIN?

If you violate her (nature's) laws, you are your own prosecuting attorney, judge, jury and hangman.

— Luther Burbank

One question that consistently crops up among the most inquisitive and thinking minds is: In this battle of Naive and Vile, who eventually wins? What exactly is the likely outcome of this ever-raging battle between the good and the evil? In whose favour do the scales tip?

Edward Moore Kennedy, the youngest of the illustrious Kennedy brothers, was being groomed as a presidential candidate. So how did his political fortunes sink in the blaze of the infamous Chappaquidick scandal on July 18, 1969? The most defining moment in Kennedy's personal and political life came after a party he attended on the Chappaquidick Island. Later that night, when (Senator) Kennedy (who had a "hushed" history of driving violations)

was driving back to Edgartown with the 29-year-old Mary Jo Kopechne, his car careered off a narrow wooden dyke bridge and fell into a creek. As the car sank, Kennedy somehow managed to escape. Mary Jo got trapped in the car and died after one hour of struggle. The Senator defended himself on national television, denying he was driving under the influence of alcohol. He justified his selfish escape on the grounds that he was 'in a state of shock' and confused by 'a jumble of emotions'. Yet, doubts were raised about Kennedy's testimony; and here's what the American public speculated as to what had transpired: Senator Kennedy, with half a mind to go down to the beach and make love to this girl, is probably driving too fast, misses the curve and goes into Cemetery Road. He's backing up when he spots a guy in uniform coming toward him. That's panic enough for the average drunken driver; but here's a United States Senator! He doesn't want to get caught with a girl in his car, on a deserted road late at night, without a licence and driving drunk. In his mind, the most important thing is to get away from the situation. He doesn't wait around. He takes off down the road. He's probably looking in the rear-view mirror to see if the cop is following him. He doesn't even see the bridge and bingo!

He manages to get out of the submerged car. She doesn't. There are houses on Dyke Road he could have gone to report the accident, but he doesn't. Because it's the same situation he was trying to get away from at the corner. Now there's been an accident and the girl is probably dead. All the more reason not to go banging on somebody's door in the middle of the night and admit what he was doing. He doesn't want to reveal himself. So he decides to get back to his house instead!

The event promptly turned into a full-blown scandal.

Investigators found it difficult to understand why he was crossing Dyke Bridge when he said he wanted to reach Edgartown, which was in the opposite direction. They also could not figure out how a 6-foot 2-inches tall Kennedy could manage to get out of the car, and a slender 5-foot 2-inches Mary couldn't. Among the harshest of criticisms was the fact that Kennedy contacted his attorney before reporting the accident to the police. The incident plagued Kennedy's attempts to seek a presidential nomination despite the early enthusiastic support for his campaign. In 1979, there was a campaign to nominate Edward Kennedy as the Democratic presidential candidate against Ronald Reagan. But the ghost of Mary Jo came calling and Kennedy could never win.

The moral of the story is that selfishness sometimes starts as an isolated, irrational and greedy behaviour in a seemingly unavoidable and difficult circumstance; subsequently it becomes a habit. One forgets the difference between protecting one's self-interest and being downright selfish. The Viles of the world are concerned only about their objectives, somewhat unconcerned with what the world thinks. Their vision is limited to the present, and conspicuously, only to themselves. But word of their selfish nature gets around. Downfall follows. This is one important reason which might tilt the scales in favour of the Naives.

However, the greatest danger to Vile comes not from Naive but from other Viles. Vile attracts and hangs out around like-minded people, and ultimately ends up getting cheated by his own kind. A story illustrates this quite clearly.

A bank manager caught at fraud was asked to pay back to the bank the embezzled amount within a day, or else face criminal proceedings. None came forth to offer help, as his reputation preceded him everywhere he went. He was almost driven to

commit suicide by jumping off a cliff in disgrace, when someone hit him hard on his back with a broom. Turning around he saw an ugly old witch-like lady with dishevelled hair staring at him. "Who are you?" he shouted.

The lady replied, "I am your godmother. I wish to know why do you wish to commit suicide?"

The bank manager then narrated his pathetic tale of disgrace and impending prosecution.

The godmother went into a trance and said, "Ask for three wishes."

He said, "Grant me $500,000."

Godmother: "Done."

"Give me a Rolls Royce."

Godmother: "Done."

"Give me a big palatial house."

Godmother: "Done."

Thrilled, he wanted to rush back to town to his palatial house, when he heard the godmother say, "But now, will you grant me a wish?"

Weighed under obligation, he couldn't refuse. She then blurted out her desire, "Make love to me."

Although repulsed by the idea of making love to an old hag, he still complied, lest his godmother should get angry and take back what she had given him. Making love to her did prove an ordeal. He some how went through it.

After the lovemaking, she asked him, "How old are you?"

"Thirty-five years," he replied.

She winked and remarked, "And you still believe in godmothers?"

At times Viles are paid back in the same coin by other Viles as above and at other times by Nature.

A Vile was seen standing at a wishing well. He selected a coin from his wallet and threw it into the well, asking for a beautiful wife. Lo and behold, an extremely pretty woman appeared. Thrilled, he took her to the church, got married to her and subsequently roamed around the town introducing his beautiful wife to one and all. When evening came, he was thrilled at the prospect of making love to his beautiful wife. It was then that she took off her wig and revealed her grey hair, removed her denture and undressed to reveal her wrinkled and sagging body. The man was horrified at the sight and yelled, "I have been cheated by the wishing well."

"No, you have not been cheated," she replied. "You threw a false coin in the wishing well! So calm down and come to bed!"

Viles are often preoccupied with how others on the racetrack are doing. This sometimes precludes them from achieving their highest potential. In a race between two athletes, one a champion runner and the other an underdog, the underdog finally won. Do you know how? On the day of the race, both men leapt towards the finishing line like leopards. When the champion was nearing the goal, and was one yard ahead of the underdog, he turned back to assess how his competitor was performing. That's precisely when his competitor overtook him from the other side. The moral of the story: Concern over the rival's level of achievement makes Viles lose the race!

A final nail in Vile's coffin is invariably hammered in by his subordinates. As Vile doesn't realise that wickedness resonates

in the organisation, he, through his behaviour, can sow seeds of guile in his subordinates too. And by showing them his bag of tricks, he unknowingly trains them to deal with him. Vile, in other words, lays a trap for himself. He doesn't realise that human wickedness brings men and their creations to ruin.

Today's era is no longer about independence; it is rather about interdependence. The trend is distinctly moving from competition to collaboration. A wise adult is one who is neither totally dependent like an infant, nor too fiercely independent like a still-wet-behind-the-ears adult, but interdependent. The wise adult understands that he can achieve much more if he joins his force with others and his character is his passport to collaborations. Vile on the other hand, through his deeds, gets his passport impounded.

To sum up, Vile may get faster off the mark but it is Naive who has the greater chance of winning in the long run. Vile would lose, because he cannot cut himself off from the past. Time is a great revealer. He buries the seeds of failure in his past because of his selfish obsession with the objective. He gets known everywhere for what he is and few wish to associate with him. A Vile, at the fag end of his career, in a heart-to-heart talk, once told me, "In life you can have friends or you can have enemies. It's my life's wisdom that you should have friends, else you can get nowhere." Vile uses guile and force. Both stir up resentment in the long run. No one likes to be swindled and no one likes to be browbeaten. The resentment of the victims grows with time. As Vile gloats over his small wins he loses the most precious possession: goodwill. He loses people's hearts. His defeat then is just a matter of time. One day a courageous Naive — more often an ambitious Vile — picks up the hatchet and lynches him to death. No tears are shed.

Having said that, remember that the good man who is dumb, has no chance of winning against Vile. It is only when goodness is coupled with wisdom and creativity, that it becomes capable of handling Viles.

Advice for All

• *When I despair, I remember that all through history the way of truth and love has always won. There have been tyrants, and murderers, and for a time they can seem invincible, but in the end they always fall. Always.*

— Mahatma Gandhi

ENDURING BASES OF POWER

MANUFACTURING GOOD LUCK

I realised with awful force that no exercise of my own feeble wit and strength could save me from my enemies, and without the assistance of that High Power which interferes in the eternal sequence of causes and effects more often than we are prone to admit, I could never succeed.

— Winston Churchill

Jeremy Goldsmith's company had a lot of business but was short of cash. Potential partners, well aware of his weakness, were offering humiliating deals to save the company. Early in July 1957, this millionaire's game seemed up. He could not pay his bills and knew that he would now have to declare bankruptcy. On a Monday morning he left his house to inform his bankers. Passing by a newspaper kiosk, he saw the miraculous headline BANK STRIKE screaming at him. This strike saved Goldsmith. It was the first such strike in two decades, and lasted more than a week.

A week was time enough to negotiate the sale of the pharmaceutical business with his main competitor. The proceeds gave him a comfortable financial cushion, which he subsequently exploited to the most.

Even to take advantage of good luck, one has to work hard. If your sailboat is parked at the shore, how will you benefit from favourable winds? If you have not practiced sailing, how would you adjust the sails when the wind blows in your favour? Chances are, if your senses have rusted due to disuse, you might not even be able to recognise the favourable wind. To be able to spot your lucky chance as well as to exploit it, you have to strive.

The right attitude is to wait for the universe to sing your song. Meanwhile, all the time, practise painstakingly on your keyboard, so that when the universe breaks into a song for you, you are ready to add your music to its lyric.

Hard work is desire, with its hands to the plough. It is a powerful magnet to universal energy. When the clouds see you sweat, they are tempted to rain.

Kindness is a strong catalyst to bring about good luck. Kindness is the fountainhead of many virtues. If we single-mindedly pursue kindness, several other virtues sprout out. If we are kind, we will be fair, polite, generous, loving and empathetic. Uncalled-for harshness, arrogance and the inability to feel the impact of one's words on others bode ill for man. Often these are the most important reasons for failure.

Humility is equally important. Humble people get more opportunities than the arrogant. And what is luck but opportunities? Why do humble people get more opportunities? Because people like their company and like to have such people

accompany them. Also, an arrogant man is disrespectful to others. If you know a friend of yours is arrogant, wouldn't you be wary of hanging around him? Would you like him to accompany you at social get-togethers or would you prefer a humble friend's company?

- Dreams are big contributors to good luck. In fact, dreams are the software of good luck.

- Wisdom also bears luck. Wise behaviour avoids mindless wars and the consequent diversion of energy.

- Wise friends bring luck by giving you right advice, sensitising you to the tenor of the times as also through their enabling presence. Wisdom is a magnet to opportunities and personal growth. Wise well-wishers help you tread the path of opportunities.

Ancient wisdom suggests there are two laws that govern our destiny. It was Pythagoras who, for the first time, elucidated these two laws — the Law of the Earth, and the Law of the Sky. Understanding these laws will also help you manufacture good luck.

What is the Law of the Earth? It is akin to the law of gravitation. It pulls you down as you strive to rise. It has its own uses. Through its constant opposition to man's will to rise, it strengthens the will power.

What is the Law of the Sky? This is akin to levitation. It pulls you up. Till the time one is banking solely on his efforts, he operates within the sphere of the influence of the Law of the Earth. Once, he recognises the existence of the Law of the Sky and falls within its purview, the results of his efforts grow manifold. Once he falls within the purview of the Law of the Sky, he starts

falling upwards. For this law to be able to pull you up and help you grow, you need the following:

- You have to be open to the possibility of its existence. Just because science has not proved its existence doesn't mean it does not exist. Newton may have discovered the Law of Gravitation just three centuries ago, but it was operational since the Big Bang, or perhaps earlier. Just because we don't have the instruments to measure the Law of the Sky, we cannot deny its existence. Instruments will come, but by then you will not be around. So, try to experience its buoyancy while you *are* and enjoy the ride.

- You need to be alive to your feminine polarity to experience it. When a man deeply falls in love with a woman, she acquaints him with the woman within him. It is then that he recognises his feminine polarity, which is his latent, soft side. This law cannot be approached through masculine aggression. One needs feminine receptivity to experience it.

- Your equations with your loved ones should be in harmony, else the psyche stays troubled. And not only do you disturb this energy field, but also cannot perform up to your potential.

- You can't actively seek to experience this law. You have to passively wait for it to include you in its ambit.

Prayer also affects your fortune. Real prayer is not just an inventory of supplies to God; it is more relational than acquisitive. You position yourself with respect to God by praying to him; you align yourself with the universal force field.

Prayer changes you. Sometimes it also influences God. That is when miracles happen.

The power of prayer is indisputable. Prayer helps you get rid of your fears as you approach the supreme power through it. It also gives you hope. By helping you tackle your fears and raising hope, it prepares you for action. Also, frequently praying to God dampens your ego. Implicit in prayer is the surrender of your ego. The wall of 'I' that you have created between yourself and the universe crumbles eventually through this surrender. And when it does, there is an upsurge. The universe sings its song in you and a thousand things begin to happen.

Advice for Naive/Vile/the Ruler

• *Kindness is in our power, even when fondness is not.*

— Samuel Johnson

• Once in a while, for good reason, you have the right to be angry, but you don't have the right to be cruel.

• *Prayer is not an old woman's idle amusement. Properly understood and applied, it is the most potent instrument of action.*

— Mahatma Gandhi

POWER OF GOODNESS

Abandon wrongdoing. It can be done. If there were no likelihood, I would not ask you to do it. But since it is possible and since it brings blessing and happiness, I do ask of you: abandon wrongdoing.

Cultivate doing good. It can be done. If it brought deprivation and sorrow, I would not ask you to do it. But since it brings blessing and happiness, I do ask of you: cultivate doing good.

— Anguttara Nikaya

From pure behaviour comes self-power, which frees a man from (many) dangers; pure conduct, like a ladder, enables us to climb to heaven.

— Fo-Sho-Hing-Tsan-King

Whoever harasses an innocent man, a man pure, without blemish; the evil comes right back to the fool like fine dust thrown against the wind.

— Dhammapada

One of the key components required for an enduring victory is goodness. What is this goodness? Goodness encompasses honesty, loyalty, kindness, empathy, gratitude, and fairness. These attributes are necessary both to achieve and sustain success.

If success brings arrogance, failure will follow. If success brings dictatorial tendencies, mutinies will erupt. On the other hand, if success brings the feeling that you are a divine instrument to look after the welfare of those around you, more success will follow. Even grandeur may come.

Can goodness be learnt? Of course. Read the following enlightening paragraph from *The Devil & Miss Prym* by Paulo Coelho.

That's right. Except that, before going to sleep, the two of them talked together for a while. Even though Ahab (the bad one, [sic!]) had begun to sharpen his knife the moment the saint set foot in his house, safe in the knowledge that the world was a reflection of himself. He was determined to challenge the saint and so he asked him: "If tonight, the most beautiful prostitute in the village came in here, would you be able to see her as neither beautiful nor seductive?"

"No, but I would be able to control myself," the saint replied.

"And if I offered you a pile of gold coins to leave your cave in the mountains and come and join us, would you be able to look on that gold and see only pebbles?"

"No, but I would be able to control myself."

"And if you were sought by two brothers, one of whom hated you, and the other who saw you as a saint, would you be able to feel the same towards them both?"

"It would be very hard, but I would be able to control myself sufficiently to treat them both the same."

Chantal paused.

'They say this dialogue was important in Ahab's conversion to Christianity'

The stranger did not need Chantal to explain the story. Savin and Ahab had the same instincts — good and evil struggled in both of them, just as they do in every soul on the face of the earth. When Ahab realised that Savin was the same as him, he realised that he too was same as Savin.

It was all a matter of control. And choice. Nothing more and nothing less."

Mahesh Bhatt, the thought leader of the Indian film industry, narrates this story, which his mother used to tell him and which takes this point a little further. She used to tell him, "There is a bad dog and a good dog in everyone of us. Whenever we are at moral crossroads these two dogs start fighting."

"Who wins?" he used to ask.

"The one you feed more," would be his mother's reply.

How do you feed the good dog? And what food do you provide?

Company of good people is one. Unshakable belief in the power that good ultimately triumphs, is the other. Believing that good lies dormant in some and a strong, selfless initiative can wake it up, is the third. If you feed the good dog within you with these three kinds of food, it is not only able to overpower the bad dog within you, but also the bad dogs around you. As the *Dhammapada* says:

No flower's scent goes against the wind — not sandalwood, jasmine, tagara. But the scent of the good does go against the wind. The person of integrity wafts a scent *in every direction.*

He (the good) doesn't need the wind to spread his perfume. He is himself a windmill powered by the energy of the Universe.

When you live with good values, brick by brick, you construct a temple through your good conduct. By the time it is ready, you realise, it is also a castle. It has made you impregnable. The robe has become the armour.

POWER OF GOOD INTENTIONS

Though a good motive cannot sanction a bad action, a bad motive will always vitiate a good action. In common and trivial matters we may act without motives, but in momentous ones the most careful deliberation is wisdom.

— W. M. L. Jay

To be able under all circumstances to practise five things constitutes perfect virtue; these five things are gravity, generosity of soul, sincerity, earnestness and kindness.

— Confucius

Both Mahatma Gandhi and V.P. Singh (the seventh Prime Minister of independent India) seemingly did the same imprudent thing — bring in reservations to uplift the downtrodden. However, V.P. Singh did so with an ulterior motive of splitting the votes and creating his own vote bank. He was not sincere to the ostensible purpose of lifting the downtrodden.

He received an unprecedented backlash. He has been criticised as the worst Indian Prime Minister and many Indians loathe him. But Mahatma Gandhi was sincere to the cause of the downtrodden. His decision may have been equally wrong but the whole country still reveres him as Mahatma (great soul) perhaps because his intentions were pure.

In his attempt to defeat the incumbent President Lyndon Johnson, Nixon tried to stall the peace conclave between Johnson and the Vietnamese Prime Minister. He managed to prevent the peace conclave to end the Vietnam War with the help of a highly connected Vietnamese lady who was close to the Vietnamese Prime Minister. Then, he harped against the Vietnam War, highlighting Johnson's inability to bring it to an end. He pounded on the incumbent President with this issue in his election propaganda. Nixon won the election, and post-victory, he went for a truce with Vietnam and grabbed the limelight offered by this peace initiative.

Then came the retribution. The fear that the tapes of his teleconversations with the Vietnamese lady may get into the wrong hands began to gnaw at him. So he decided to have the tapes stolen from the library where they were housed. The men who were entrusted this job got caught and the Watergate scandal and Nixon's crash followed. It was again a case of bad intentions that boomeranged.

POWER OF GOOD THOUGHTS AND GOOD WORDS

The fingers of your thoughts are moulding your face ceaselessly.

— Charles Reznikoff

If thoughts corrupt language, language can also corrupt thoughts.

— George Orwell

The real art of conversation is not only to say the right thing at the right time, but also to leave unsaid the wrong thing at the tempting moment.

— Dorothy Nevill

Before you speak, ask yourself, is it kind, is it necessary, is it true, does it improve on the silence?

— Sai Baba

Wisdom is knowing when to speak your mind and when to mind your speech.

— Anonymous

Our thoughts mould our lives. They are the hidden architects, the unseen pilots. If the thoughts that we have are good, life automatically steers us towards peace and happiness. On the other hand, if our thoughts are poor and petty, our destiny would be no different. Because thoughts are the seeds for our words, actions and behaviour. Our character emerges from their nursery. Therefore, try to entertain and nurture good thoughts. If you can do so regularly, the rainbow of your life is not far. In fact, good thoughts unobtrusively weave the fabric of your rainbow.

Words are also important. They too influence our thoughts. In fact, words are the currency of thought. Have you noticed that you can't think without words? We tend to use the same words that we speak in our thinking. Therefore, one should use good words full of possibilities in one's language.

POWER OF CHARACTER

Each man takes care that his neighbor shall not cheat him. But a day comes when he begins to care that he does not cheat his neighbor. Then all goes well — he has changed his market-cart into a chariot of the Sun.

— Ralph Waldo Emerson

Show class, have pride, and display character. If you do, winning takes care of itself.

— Coach Paul 'Bear' Bryant

What is morally wrong can never be advantageous, even when it enables you to make some gain that you believe to be to your advantage. The mere act of believing that some wrongful course of action constitutes an advantage is pernicious.

— Marcus Tullius Cicero

An ounce of loyalty is worth a pound of cleverness.

— Elbert Hubbard

In the alacrity of business we have retained the fire of idealism and in its glow we have come to recognise:

That no wealth or power can be more valuable than our dignity.

No loss of profit can be more critical than the loss of credibility.

No skills or qualifications can substitute the integrity of our character.

— J.R.D. Tata

The world, as I said, is moving from competition to collaboration. One can achieve much more if people are ready to collaborate with him. Character is one's passport to collaborations, to friends. No one wishes to befriend a cheat. The man with character has many takers. He can pick and choose. His credibility is his ticket to success.

One must indeed try to befriend those who are equally virtuous. This is not always possible as people come in all shapes, sizes and constitutions. One comes across both Naives and Viles. Therefore, it is important that the world must know what you stand for, as well as what you won't stand. The world must clearly know where you are coming from. This knowledge itself becomes your armour against the Viles of the world because through their interactions with you, Viles know that you will not step into the muck with them. So speak up and let them know the rules of your game — the fibre of your fabric.

POWER OF COMMITMENT

Promises are like the full moon: if they are not kept at once, they diminish day by day.

— German proverb

There is much wisdom in doing what you say, in practising what you preach, in walking your talk. This makes people trust you. This trust works for you when the chips are down. When your deeds are in tandem with your words, you are in sync with the order of the universe — you are in tune with the Tao. The desire to do what you say also makes you sensible in promising. You will not make false promises. In fact, you may try to under-commit and over-deliver — under-commit not to avoid the work required to fulfil your intention but to surprise the other party. Keeping your commitments, builds honour. Honour builds character. And character is destiny.

How does honour build character? The honourable defend their beliefs publicly. Then they need to live up to these beliefs they have espoused. To keep in tandem with what they have said, slowly they become what they publicly have claimed to be.

POWER OF FRIENDSHIP

The first method of estimating the intelligence of a ruler is to look at the men he has around him.

— Machiavelli

Sometimes our light goes out but is blown into flame by an encounter with another human being. Each of us owes the deepest thanks to those who have rekindled this inner light.

— Albert Schweitzer

I value the friend who for me finds time on his calendar, but I cherish the friend who for me does not consult the calendar.

— Robert Brault

A friend is our needs answered.

— Khalil Gibran

The term "friend" is used very loosely. In common parlance, it may refer to:

- Friendly acquaintances, such as neighbours and business mates
- Developing friends
- Close friends

A few of your acquaintances and developing friends could one day turn into close friends, provided you share a common worldview with them. By 'worldview' I mean common likes, dislikes, interests and values. Sharing a similar value system is most critical for an enduring friendship.

Don't load a newborn friendship with expectations or your tragic life experiences (laughter is quickly shared; no one wants the weight of your crosses). Friendship, at its base, implies some kind of mutuality. But it takes time for the transaction to begin. If you overload it too early, the other guy might run away.

Also, the idea should be to give and take rather than to take and give. Do unto others as you would want them to do unto you. But you do it first. Start by giving rather than by taking. Over time this strict mutuality of give and take disappears and is replaced by a feeling of wanting to do whatever one can for one's friend. Still, in times of differences, the shadow of the scale may appear again. So one must strive to maintain mutuality. This exchange even gives some kind of a spice to friendship. Friends get to share their surpluses and fill up their shortfalls. Having said that about mutuality and exchange, I must rush to add a close friend in times of need will not ask 'why' but 'where'. It is this unconditional readiness to stand by you that gives friendship its power. In a close friendship, each of the friend knows that the other would stick, however, great the pressure, would extend help before it is asked, seek no self-glory and everlastingly keep his word.

What are the best places for finding friends? The family is perhaps the best cradle of friendship — the best source of friends. If one can be a friend with one of his family members, he often has a deeply loyal friend.

School, in my view, is not the best source of life-long friends. Why? Because when you are in school, your judgment of character is not strong. You may befriend people because of unimportant exterior appearances and traits. But eventually, you realise as you grow up, it is internal compatibility that matters.

The professional sector that you operate in can bring in some friends. But immediately contiguous areas where jealousy exists will yield a poor harvest. As it is, one can't have many close friends, because keeping close friends means keeping contact and giving a lot of time.

Close friendships also require your love and respect. Without love and respect you can't nourish a close friend. Giving love and respect is hard work. If love is action, respect is even tougher action. You are really a close friend if you strive to bring the best in your friend and not the worst. A close friend is an enabler. This doesn't mean that he is not a critic. You owe your loyalty to your friend, not your agreement. Your criticism however should be directed to holding a mirror to him or to showing him a better way and not to nag him or to make him look inferior. Your critique also should be well timed. You can gently step on his toe to correct him not when the milieu resembles a crowded queue but when it is more like the dance floor.

A close friendship requires keeping information confidential. A close friendship means sharing your friend's hard times as well as his successes. Failure of a friend is not the number one reason for casualty in a friendship; success is.

You must be able to share a friend's success. You should be able to genuinely clap on his achievements. When one claps, it seems only his hands are moving, but actually, his feet also move towards those he is applauding. He takes the first step towards being like them. The echo of his clap also announces the start of his journey. When you are the successful friend, you must be able to clinically evaluate the extent of your success and even if the differential is really significant, digest it without unilaterally declaring yourself the captain and rocking the boat.

Also, close friendships should not be broken on a trivial issue. They take a lot of effort to form and close friends are very difficult to come by. A patching up mechanism should be institutionalised between close friends.

Lastly, a close friendship demands that you speak well of your friend. You must realise that because of your proximity to him, it is your words that define him the best. Also remember, you are not talking about just anyone; you are talking about your sheet anchor.

A good friend is loyal and his loyalty gives you sustenance, an anchor. His presence is salubrious to your growth, if he too grows in a similar direction. You can serve as a source of inspiration for each other, draw strength from each other, grow through your interactions and be each other's cushion when one falls.

POWER OF CONSISTENCY AND SILENCE

He that resigns his peace to little casualties, and suffers the course of his life to be interrupted by fortuitous inadvertencies or offences, delivers up himself to the direction of the wind, and loses all that constancy and equanimity which constitute the chief praise of a wise man.

— Samuel Johnson

...and such is the limitation of the human powers that, by attention to trifles, we must let things of importance pass unobserved; when we examine a mite with a glass, we see nothing but a mite.

— Samuel Johnson

The tree of silence bears the fruit of peace.

— Arabian proverb

And silence, like a poultice, comes to heal the blows of sound.

— Oliver Wendell Holmes, Sr.

From time to time in any relationship jolts may come. It is then you need consistency. For relationships to endure, consistency of behaviour is required. Consistency of behaviour gives a shock absorber to sudden erratic behaviour from the other party. Many a time the desire is to retaliate in kind. An equanimous mind will help you resist the temptation. You can handle such storms even if the mind is not still. How? By keeping your tongue immobile.

To greet a tantrum of a dear one with silence you need to be able to take a macro view of the relationship. When you do this his tantrum is just a small blip on a large screen. Overall the relationship is fulfilling for both the parties. It is a rich canvas of mutually nourishing feelings just stained in a little corner. This kind of a macro view will generate understanding and will give you reasons why you should not allow the stain to spread.

Don't think if you are silent you might be taken for granted. Silence also speaks. If your silence is of a mature variety the other party will, once the storm has passed, unmistakably hear it. At the right occasion, you can bring the point up and vent any pending resentment in a way that is reformative. In fact, consistency of behavior is contagious. If you are consistent the other party learns from your example and follows suit.

POWER OF ANGER/COMPASSION

I have learned through bitter experience the one supreme lesson: to conserve my anger, and as heat conserved is transmitted into energy, even so our anger controlled can be transmitted into a power that can move the world.

— Mahatma Gandhi

All of anger is not bad. Anger is an energy. It needs to be channelled. If you recklessly vent it right away then you get caught in the vicious cycle of an angry response leading to an angry response from the affected party and so on. If you bottle it up, it corrodes you from within and can erupt any time.

How can you channel your anger? Be witness to your anger and label it. Don't get involved in the emotion, just label it and watch it. And how do you label it? Just say to yourself that *there is anger* and not that *you are angry.* Labeling it distances you from it and watching it, takes the violence out of it.

With practice, you can learn to transform this energy in to a beautiful byproduct, i.e. compassion.

This process also radiates you with an ethereal energy. The birth of compassion also changes our style of speech. We, then not only pay attention to the words we speak and their tone but also our speech starts reflecting our concern for others. Our words begin to help and heal rather than wound and destroy.

POWER OF SENSITIVITY

No trumpets sound when the important decisions of our life are made. Destiny is made known silently.

— Agnes DeMille

Be on the alert to recognise your prime at whatever time of your life it may occur.

— Muriel Spark

The sensitive man sees what others don't. Then one day he comes to know what others won't. It is on this day that he moves from brilliance to genius.

What is this sensitivity?

You remember the story of the bird, which I narrated in the chapter, *Catching Signals?* It was sensitivity at work that helped it catch the signal sent by its relative. It was sensitivity that helped it emerge from a crisis. Sensitivity can also similarly help you

avert crises and exploit opportunities. Sensitivity is alertness; it is also wakefulness. At another level, it is also receptivity.

One needs to be not only socially but also psychologically and spiritually sensitive.

While visiting a pediatric hospital in Kolkata, I saw a boy, about thirteen-years old, selling balloons at the gate. As I walked past him, I could not but silently admire his genius. Once inside, I met the doctor who owned this hospital and, during the course of our conversation, I told him I had seen a genius at the gate. He said, "If you are talking about the little boy who is selling balloons at the gate, you are damn right. This boy sensed that kids who are being brought to my hospital start crying at its very sight (fearing an injection or some bitter medicine) and the parents then need something to pacify them. They end up buying his balloons to please their kids. Sometimes, in case of an exceptionally stubborn wailer, the hospital staff also buys one from him. Six months ago, when he started hawking his balloons, he used to come barefoot to peddle his balloons. He has flourished since and has a moped now. He has also invested in new equipment and might even have a decent bank balance..." Why did we both feel that this little boy was a genius?

Because he had gauged and understood the social milieu of the hospital and spotted the commercial opportunity that this setting presented. He was socially sensitive and his social sensitivity yielded him rich dividends.

Years ago, I was sitting with my friend's five-year-old daughter who was taking me through her drawing book. We came to a picture, pointing to which she said, "This is my future house."

Looking at the picture, I asked, "Your house will have a chimney?"

She replied, "No, this is a dish antenna."

There was a sudden flash of realisation. I was interacting with her from my schema, not understanding where she was coming from.

I was being psychologically insensitive. Psychological sensitivity is of paramount necessity.

Spiritual sensitivity has not been adequately studied in the West. But for a whole and complete life, it needs to be explored.

Spiritual sensitivity is the understanding that the world is more than just matter, body and mind. Spiritual senstivity is the innate ablity of the human psyche, which helps our antennae connect to the heart of the universe itself. It is a faculty developed over million of years that allows us to find solutions to our problems by tapping the universal spirit. It has no neccessary connection to religion. A religious person

may be spiritually sensitive. But being religious does not guarantee that a person would be spiritually sensitive. Spiritually sensitive people exist more often outside the confines of organised religion. A person is complete only when he is spiritually sensitive too. He can then listen to those around him and take in the divine messages in their words. This is one way how he listens to what the universe is trying to say to him. His sensitivity makes him receptive till one day the universe speaks to him in myriad ways and he becomes a channel for the wisdom of the universe.

POWER OF INTUITION

There is a road from the eye to the heart that does not go through the intellect.

— G.K. Chesterton

Life cannot be classified in terms of a simple neurological ladder, with human beings at the top; it is more accurate to talk of different forms of intelligence, each with its strengths and weaknesses. This point was well demonstrated in the minutes before last December's Tsunami, when tourists grabbed their digital cameras and ran after the ebbing surf, and all the 'dumb' animals made for the hills.

— B.R. Myers

Trust your hunches. They are usually based on facts filed away just below the conscious level.

— Dr Joyce brothers

Choices are the hinges of destiny.

— Edwin Markham

Intuition is pure, untaught knowledge. It is a direct perception of truth or any fact, independent of reasoning. Logic can support intuition, but not all the way. After a point, logic has no rights of entry. Intuition goes beyond logic but it is not against logic. When you are operating in the intuitive domain, you have to remember some things have to be believed, to be seen or felt. They are real but gossamer fine, which current paradigms of logic cannot explain.

Once you have experienced the versatility of intuition, your faith in it deepens. A kind of transmitter to the universe is born. Your exchange begins.

POWER OF GRATITUDE

An attitude of gratitude creates blessings.

— Sir John Templeton

The art of acceptance is the art of making someone who has just done you a small favour, wish that he might have done you a bigger one.

— Russell Lynes

Too many people miss the silver lining because they're expecting gold.

— Maurice Setter

A Nobel Prize-winning research on stress showed that living with an attitude of gratitude consumes least energy. In contrast, having an attitude of revenge consumes the maximum amount of energy, almost like shorting a battery.

On looking back at the major achievements in your life, you will notice somebody had helped you in crossing

those milestones. This help could have taken several forms — from someone having been instrumental in getting you an opportunity to someone motivating you to take that trail. That person may be living or dead, big or small — that is not the point.

The point is he either carried you to the opportunity or gave you the mental fuel to approach it. An attitude of gratitude towards such people will further fuel your growth. In time this attitude will transform and turn into a larger sense of gratitude towards the universe. This sense of gratitude and knowing the universe has blessed and is blessing you, attracts what you want on the principle that 'like seeks like': things flow to the person who already appears to have it.

Real gratitude isn't just thanking, it's bowing in thanks. When you bow thus, you start moving closer to those who you admire and feel grateful towards. That means gratitude develops you. It is perhaps for this reason that Jainism preaches the chanting of the *namokaar mantra*. This *mantra* is a salutation to five types of masters. Salutation is made to:

- *Arihantas*: Those who have no enemies; which means they have conquered all opposing beings as well as discordant thoughts and come to a state of total poise.
- *Siddhas*: Those who command Nature.
- *Acharyas*: Those whose thoughts, words and deeds are in perfect alignment.
- *Upadhyayas*: Those Acharyas who also teach others.
- *Sadhus*: All the great eternal souls.

POWER OF SHARING

A true master is not the one with the most students, but one who creates the most masters.

A true leader is not the one with the most followers, but one who creates the most leaders.

A true king is not the one with the most subjects, but the one who leads the most to royalty.

— Neale Donald Walsch

When one person teaches another there are two who learn. The master also learns.

— Zen saying

Whatever I shared is still mine, the rest I have lost.

— Gurjief

It's not what you gather, but what you scatter that tells what kind of life you have lived.

— Helen Walton

If you want happiness for an hour – take a nap.
If you want happiness for a day – go fishing.
If you want happiness for a month – get married.
If you want happiness for a year – inherit a fortune.
If you want happiness for a lifetime – help others.

— Chinese proverb

Big people become big by making others big.
Small people become big by making others small.

— Ashok Kapoor

An important question is whether one should share what he knows and what he has with others. Some say if you share your wealth, it dwindles; if you share your wisdom and insights, you lose your uniqueness. It sounds logical, but it isn't real. Though, if you share with these logical apprehensions, it may come out to be so. So when you share with the spirit of helping others to develop and grow and as a means to thank the Lord for the bounty he has given you, it is then, you experience the power of sharing. Because then, the universe shares with you.

All successful people would admit that chance has played a big role in their success or enlightenment. Chance is the currency through which the universe has shared its bounty with you. Is it worried that its wealth will reduce by sharing it with you? Is it looking for gratitude in return? It shares with you in the natural spirit of sharing. It shares to help you; to make you happy. This is how one must share. By sharing thus, you share as the universe has shared with you. This commonality brings you in the inner circle of the universe. Naturally as an inner-circle member, your share in the bounty of the universe increases.

In fact, you can't receive without giving. Yoga says one

cannot inhale deeply unless one exhales strongly. This isn't just logic which applies to the process of respiration. It is almost a cosmic cyclical law that governs all our transactions. Creators of wealth all over the world know money grows by circulation. This law governs not only the field of wealth but also that of ideas. In fact, the only rider here is that one can't share what he doesn't have. And to have, one needs to accumulate. So your accumulation and sharing should form a cycle — accumulate-share-accumulate and so on. Deep expiration will create the necessary space in your being to accommodate the largesse of the universe.

When sharing, also understand that some of your friends may find it difficult to ask. To them you have to give without their asking, by sensing their needs, by keeping an arm around their shoulders, so they can ask. Also don't speak while giving. Because when you give, the ego wakes up. It might want you to tell the receiver what a big thing you are doing for him, or it might want you to ensure you get the beneficiary's long-term gratitude in return for what you are giving, or it might want you to tell him that few would share with him as you are doing. By keeping quiet while giving, you prevent the ego from spoiling it. You retain the grace in giving.

I have heard about a corn farmer in Canada, who won all the quality awards, year after year. Researchers, who went to study what was it that he did which differentiated him from the other contestants, were amazed by their findings. They found he shared all his best practices with his neighbouring farmers. When asked why he did so, he replied, "Because corn is a cross-pollination product. It is important that the pollen grain coming into my farm from the neighbouring fields be of good quality. It is

for this reason that I share all my secrets with my neighbours. Moreover, once I have shared, I am empty and hungry for more learning. So I try to acquire more state-of-the-art knowledge. Thus, sharing helps me in my quest to keep ahead."

There is also a kind of sharing which immortalises you. When you share what life has taught you, you put your life into others. You make yourself immortal. So share. By sharing, your wealth and uniqueness will not be a casualty. It will, on the contrary, be the biggest beneficiary.

POWER OF RELAXATION

Take rest; a field that has rested gives a bountiful crop.

— Ovid

The marksman hitteth the mark partly by pulling, partly by letting go.

— Egyptian proverb

You will soon break the bow if you keep it always stretched.

— Phaedrus

Just as preparation and training are required, so is relaxation. While effort exerts the muscles, relaxation helps them form. Any weight trainer would advise you that the muscle, which you have exercised, must be rested for 48 hours before you exercise it again. Why? This gives it the necessary time and rest that it requires to develop. This is also the reason why one is advised to use the spa while following an exercise regimen. These relaxing schedules help one rejuvenate and enable him to undertake even more

rigorous workouts. What is true for the body is true for the mind too. So relax when you are tired or bored. More battles are lost for want of sleep than for inadequate preparation.

There are several ways to relax. Meditation is a good method. However, I have found that people who operate in highly competitive environments such as sports, films, business and politics are often too worked up to be able to meditate. To such individuals I have recommended bathroom singing to good effect. The song, that arises spontaneously while bathing, really springs from the soul. As the water goes down on you, the song wells up. In my view, bathroom songs are true hymns and bathroom singing is a practical way to relax even in taxing situations.

Some other simple ways to relax are :

- Soak in warm tub: Lying in a tub on your back is almost as if you are in the liquid environ of the womb. This takes you back to secure and serene environment.

- Walk slowly and wear loose clothes: There is definite connection between your gait, clothes and stress. The brain is used to thinking fast when you walk fast. You need to slow down your brain to de-stress. So when you slow down your gait, you are also slowing down your thoughts. You can thus reduce flurry in the mind by using the body-mind connection. When you wear tight garments, you tend to be in an aggressive mood. Loose clothes symbolise zero restrictions.

- Be one with nature: Take a walk, preferably in a green environment, enjoy the dance of waves and gaze at the stars. When we star gaze, we realise how miniscule our problems are and that we are only a speck in the universe.

- Try a cold eye compress: When fatigue sets in, the brain rarely tires. It is usually your senses that wear out, your eyes being the most delicate of the six senses. Using a cold eye compress while lying on your back is an excellent stress buster and an effective relaxation technique.
- Listen to Sufi music: The whirling sensation produced by Sufi music has a soothing effect.
- Have sex: Robust or tender sex is also one of the best ways to relieve stress.
- Learning ego management: Ego management is important especially when you acquire power and success. The more your ego grows, the more fragile it becomes.
- Develop a time management system: Every individual's job has a certain time pattern. Catch your pattern and build a time system that will help you organise your work better. Once the system is in place, you will realise that you have a lot of spare time to do what you essentially love doing.

POWER OF LAUGHTER

He who laughs, lasts.

— Mary Poole

A person without a sense of humour is like a wagon without springs, Jolted by every pebble in the road.

— Henry Ward Beecher

Laughter is good for your digestion, is supposed to lower the levels of stress hormones, boost immunity and even massage your internal organs. It is good for your spiritual health as it is a kind of meditation too. Have you noticed while laughing you are completely free of thoughts and tension?

Moreover, if you can develop the ability to laugh at yourself, it helps in subduing the ego. While laughing people forget their differences and come closer to each other. In that sense, laughter is also social grease: it not only opens the lips but also unknots the hearts.

Hence, it serves as a catalyst to collaborations and therefore to power. It is true that seven days without laughter make one weak.

Laughter is also a key to the vault of creativity. Laughter loosens the associations in our mind. In some way, this makes the mind supple and capable of forming new associations.

Having said that, laughter that emerges from the following three kinds of humour doesn't have great nutritional value:

- Humour caused by ridiculing others:
- Humour caused by making oneself look ridiculous and
- Humour caused by making sex look dirty.

These are *junk humours*. The laughter they provoke is not of the redeeming value and could even put off some of us. Almost all other varieties of laughter are redeeming. A smile is a good cosmetic and a laugh is a fine tonic.

CHAPTER SIXTEEN

POWER OF BALANCE

Develop the mind of equilibrium. You will always be getting praise and blame, but do not let either affect the poise of the mind: follow the calmness, the absence of pride.

— Sutta Nipata

There are two kinds of balances: one that the quote above speaks of, which can be called equanimity. This kind of balance raises your immunity towards whatever happens around you. Your external circumstances don't affect your internal conditions. Success doesn't make you behave recklessly and failure doesn't depress you. Praise doesn't go to your head and criticism doesn't sting your heart. You become almost unflappable.

The other type of balance is the one that a man acquires when he moves on the middle path, when he avoids extremes and follows the golden mean. Then, for example, he is not a coward, nor is he rash; he is courageous. Similarly, between pride

and diffidence, he chooses modesty; between miserliness and extravagance, liberality; between depression and buffoonery, good humour; and between belligerence and flattery, friendship.

One who attains to a balanced walk of this kind finds that when he so walks, happiness walks alongside him. It eludes him only when this equilibrium is upset and that too for only as long as he can't find his centre again. When he is balanced like this, he is in tune with the Tao of the universe and open to all possibilities.

THE WONDER OF LOVE

Love is a power in itself. Love is not an apolitical force. It is an antipolitical force. Because it is antipolitical it is not just a force to reckon with. It is the force.

Power is of two kinds. One is obtained by the fear of punishment and the other by acts of love. Power based on love is a thousand times more effective and permanent than the one derived from fear of punishment.

— Mahatma Gandhi

Men greet each other with a sock on the arm, women with a hug, and the hug wears better in the long run.

— Edward Hoagland

Love is action. When your hands want to help others, when your feet run around for the poor and needy, when your eyes see their misery and your ears hear their sighs, then you love them. Even after so much work love is effortless. It doesn't tire.

But remember, as someone has said, to make this world a loving place, you have to first show it a loving face. What does this mean? It means that in the beginning, love is hard work and only later love becomes a self-propelled phenomenon. You have to begin by behaving caringly and kindly. In time, reciprocation will come and then love will take root on either side. The masks will become the faces. Then productivity rises, relationships blossom and there is music in the air.

LOVE AND DISCIPLINE GO HAND IN HAND

He who lives without discipline dies without honour.

— Icelandic proverb

This is not healing to the abuser, but damaging. For if the abuser finds that his abuse is acceptable, what has he learned? Yet if the abuser finds that his abuse will be accepted no more, what has he been allowed to discover?

Therefore, treating others with love does not necessarily mean allowing others to do as they wish....

Thus, in order to 'have' yourself as a man of peace, you may have to give up the idea of yourself as a man who never goes to war. History has called upon men for such decisions.

The same is true in the most individual and the most personal relationships. Life may more than once call upon you to prove who you are by demonstrating an aspect of who you are not.

— Neale Donald Walsch

Have you ever wondered why Jesus Christ, a true man of love, chased out the moneychangers from a temple with a whip? Perhaps, because he knew love wouldn't work there. Or he felt the time for love was up. It was time for discipline.

So, how does one become capable of love as well as discipline? How does one know, in a particular situation, if it is love that's required or is it discipline that's necessary? And how does one know whether the response he chose was appropriate or not? Let me suggest the answer through an example.

Suppose a peon in my company comes to me for financial help to enable him to buy textbooks for his son. I give him the amount he seeks without any question. He goes away happy. Another peon comes with a similar request for financial help. This is what I tell him, "Handle your finances better. No help will be provided. Thank you and goodbye." Disappointed and dejected, he leaves my room, with tears in his eyes. But I am at peace with myself. Because I know that this peon is a drunkard and is careless with his money. My inner voice, therefore, does not protest when I summarily dismiss him.

Were I to behave in this manner with the first peon (a responsible colleague), my inner voice would have protested against such unjustified behaviour. If you can train yourself to listen to this inner voice, you become capable of love as well as discipline. You also know which is the appropriate response in a given situation. When your inner voice does not protest, you know you are doing the right thing, be it loving or chastising.

WISDOM OF LEAVING THE PAST BEHIND

The day the child realises that all adults are imperfect, he becomes an adolescent; the day he forgives them, he becomes an adult; the day he forgives himself, he becomes wise.

— Aiden Nowlan

Growth in wisdom is measured by decrease in bitterness.

— Freidrich Nietzsche

There is no wise man, I know, who hasn't committed some acts of folly in his past. His wisdom lies in taking his lessons and then not thinking of those incidents again.

All of us have at some time felt afraid, have failed in our duties or have hurt someone we loved. But there is the hope of being better than what we were. To move on, by replacing our remorse with this hope, is wisdom.

From our childhood we are fed with programmes. Some of these programmes remain with us even when they have lost their utility.

They remain with us even when we have reached the stage of evolution that demands a programme, which is opposite to the one that we are carrying. These once-relevant-no-longer-useful programmes are not only acquired during childhood; they get scripted even in adulthood, when our defeats and victories write such programmes for us. The age, weather and climate change but the programmes stick. These programmes need to be relooked at. The long living and enabling truths in them should be retained, while all else should be abandoned. You need to sincerely confess your sins and then forget them. You need to take lessons from your defeats and forget them too. That is when you get rid of the past in a way that benefits you. Then the past leaves you with its lessons; not its trauma.

SURMOUNTING SUPERSTITIONS

A superstition is the presumption of a cause-and-effect relationship that can neither be conclusively proved nor refuted. Usually, superstitions are without merit and they often take birth because we have mistaken a coincidence for a causality.

B.F. Skinner, the noted behavioural psychologist, conducted a classic experiment in 1948 showing that pigeons could become superstitious. He put eight hungry pigeons into cages and dispensed food pellets to them regularly. They were fed every 15 seconds, wholly independent of anything they did. Six of the eight developed bizarre rituals, all different. For instance, one banged its head against a corner of the cage while others spun around, tossed and rocked back and forth in particular ways and so on. Dr Skinner surmised that the pigeons were carrying out arbitrary actions when the food first appeared. They got fed again after replicating the gestures, although the pellets would have come anyway. They had become superstitious.

This phenomenon of the birth of a superstition has been shown to apply broadly to humans as well as to animals. That is, events that occur repeatedly seem to have a dependency, irrespective of a genuine link. So one source of a superstition is coincidence.

The other source of any superstition is culture. Let me give you an example. Just before my first trip abroad, to Paris, I misbehaved with my servant (something I still regret). One day after reaching Paris, I could not find my passport. After looking for it in my baggage, and not finding it, I sheepishly had to announce the loss to my colleagues there. Hell broke loose. A new passport was to be arranged, in 24 hours. Thereafter, visas had to be obtained for other countries, which I was scheduled to visit for my induction. It was mayhem. Finally, thanks to a friend and after a lot of toil, sweat and embarrassment, I could get a new passport and fresh visas. A few hours later, while pulling out a paper from my satchel, my hand rubbed against a little book.

It was my old passport.

I had never lost it. It was tucked away in my bag all the while. I could not understand what had happened. Now I do. I had misbehaved with my servant and it was playing on my mind. Having been deeply steeped in karmic philosophy, I was awaiting retribution. It didn't come on its own, so I brought it upon myself. I now know that it was not God who was keeping account. My socialisation was at work — it squared up the accounts.

Superstitions stem from conditioning and fear or even from being greatly attached to a favourable outcome, where the stakes are high. One Bollywood star takes the same route daily to his shooting site, no matter in which part of city it is taking place. Even if the other roads are less congested or better metalled, his preferred route remains consistent.

Such superstitions weaken people and make them inefficient. A car dealer in Delhi once told me that often, due to pressure of sales targets, the best prices on a car are offered on the last day of the month. But if the last day of the month is a Saturday, sale comes to stand still in spite of the discount. Why? Because many people in India believe that Saturday is not an opportune day for purchase of metal. So when do they buy it? A day later, the next month, even if it is at a higher price.

How can one get rid of superstitions? You need to spot the source. Where do they stem from? They almost always stem from greed and fear. Seeing their origin will often make you chuckle when you notice the absurdity. Often the superstitions will then gradually drop on their own. Your awareness that they are absurd will uproot them.

WISDOM OF GOLDEN HUMILITY

Angels can fly because they take themselves lightly.

— G.K. Chesterton

Humility does not mean you think less of yourself. It means you think of yourself less.

— Ken Blanchard

One of the symptoms of an approaching nervous breakdown is the belief that one's work is terribly important.

— Bertrand Russell

If you want to get rid of your enemy, the true way is to realise that your enemy is delusion.

— Kegon Sutra

Egotism is the anaesthetic that dulls the pain of stupidity.

— Frank William Leahy

It is always the secure who are humble.

— G.K. Chesterton

Ego is a form of defence. Ego helps you defend your interests. The important thing is to learn when and how to use it, and be aware of when you have become its slave. When, as you enter a room, your eyes ask others this question, "You know who I am", you have been enslaved by ego. If this happens, your ego will trouble you a lot. The three big problems ego brings are:

- Ego makes you lonely.
- Ego makes you vulnerable to hurts and makes the hurts feel bigger. (In contrast, a humble person is practically immune to being hurt. Humility also gives him a peaceful spirit.)
- Ego may also make you imagine slights. I once went to a resort in India. A friend of mine, who had instructed his staff to take good care of me, owned it. My car reached the porch. Seeing no one there to receive me, I felt affronted (I must have been on some ego trip). Using my mobile phone, I called the manager, told him that I had arrived and asked him if he were in his office or out on an errand. He told me that he was in his office and this annoyed me further. In less than a minute, he reached the porch and welcomed me graciously. I still stayed stiff for the whole day, till I, by chance, found that his room had no window and he couldn't have seen or heard my car coming in to the porch!

Is humility *egolessness*? So I was told and so I read. But the answers didn't satisfy me. As I said, in one's childhood one is fed with many programmes, e.g. "don't touch the electricity switch". It is a totally justified programme for one's childhood. But if one grows into an adult and is stuck with this programme, he would not be able to experience the magic power of electricity, such as

computer, internet and air-conditioners. This means there comes an age when one must break such programmes. Similarly at times, in the beginning or middle of your career, it might really be required for you to subdue your ego. In fact, if you don't, then it may sound your death knell. But a time comes when you are required to play the leadership role. Here, once in a while, you may need your ego. Why? You are the face of the organisation; you are not only the chief, you are the chief guardian and therefore sometimes you do need to register your presence with confidence.

Your ego should be like a raincoat. For most of the year, you don't need it. It is not a part of your daily wear. You need it only when it rains. You don it then. When the cloudy weather is over, it goes back in the closet.

What is the right way to handle disrespectful people? One way is to look at them as you look at a mud poodle. You see it; you sidestep it. You don't get angry at it. You don't fret about it. In any case, you should not react to any slight. You should respond to it consciously. Why consciously? Because then your reaction is measured. If you react, you will overdo it. You must also understand that you can communicate your displeasure through silence and body language as well. This kind of communication or response does not leave behind scars like words do.

Balance is important. Taking yourself too seriously is as bad as not taking yourself seriously enough. The middle path of sobriety is better. Your interaction should be polite, not only with other leaders but also with everyone within your own organisation. And yet, it should be marked with grace. This is what I call, *golden humility*.

There are other types of humilities too, for example, the humility stemming from weakness. This is forced humility. One is humble because one has no choice.

Then there is what can be called *geriatric humility*. This humility comes to many as they age. It doesn't spring from any transformation within. It stems from the deterioration of physical strength. To be able to carry ego, one needs a certain kind of aggression, which requires physical robustness. For most people, with age this sturdiness withers. Recognising their waning strength, they are left with no option but to be humble. This variety would still like to walk with its heads in the air but the deteriorating skeletal system doesn't allow it to do so.

There is another kind of humility, which stems from the ego itself. Where a powerful person poses to be humble, as this powerful-yet-humble image gets him even more attention because of the praiseworthy contrast in the image. This kind of humility prepares a feast for the ego. It is a subtle game that ego is playing here. But this type of humility is also artificial. In fact, it is hypocritical.

Golden humility is the more natural variety, where you give respect and command respect. It is the precursor to totally organic humility — to the ability to sense God's presence within all, big or small, including yourself. Golden humility is the stairway to this more sublime variety of humility.

POWER OF WISDOM AND MATURITY

Science is organised knowledge. Wisdom is organised life.

— Immanuel Kant

The road to wisdom? Well it's plain and simple to express: Err and err and err again, but less and less and less.

— Piet Hein

The art of being wise is the art of knowing what to overlook.

— William James

Force without wisdom falls of its own weight.

— Horace

Authority without wisdom is like a heavy axe without an edge: fitter to bruise than polish.

— Anne Bradstreet

In my view, maturity means how to behave, what to say, when to say it and how to say it. It is a behavioural trait. Wisdom, on the other hand, means the insights about life — insights that hold

good across different contextual domains. Wisdom is a broad concept. From the perspective of wisdom, to succeed in any sphere of life — be it material, physical, psychological, social or spiritual — one must succeed somewhat at all of them. This view appreciates the intrinsic wholeness and interconnectedness of life.

Wisdom means the ability to see the true nature of things and then make the choices, which are true, right and lasting. It is to be informed by the sum of learning through the ages using multiple forms of intelligence — reason, instinct, intuition, heart and spirit.

True wisdom is grounded in past experience or history and yet it is able to anticipate the likely consequences in future. It balances self-interest with public good. Wisdom helps one sense, work with and align oneself and others to life. It helps one progress materially, physically, psychologically, socially and spiritually.

Can maturity and wisdom be acquired? It is indeed difficult to acquire these traits. Most people die unwise. Age doesn't always bring maturity and wisdom. Usually, age comes alone. As Tennyson said, "Knowledge comes but wisdom lingers." One can bring maturity and wisdom in his life by forming enduring associations with the wise, through reading and observing the world around him. The innate wisdom of the wise and that gathered out of his own experience then lingers on like a perfume.

EPILOGUE: GOING BEYOND WISDOM

*Observe the wonders as they occur around you. Don't claim
them. Feel the artistry moving through and be silent.*

— Rumi

*Be a Columbus to whole new continents and worlds within
you, opening new channels, not of trade but of thought.*

— Henry David Thoreau

*Faith is an oasis, which will never be reached by the caravan of
thinking.*

— Khalil Gibran

*I believe though I do not comprehend, and I hold by faith what
I cannot grasp with the mind.*

— St. Bernard

*What you do is of little significance; but it is very important that
you do it.*

— Mahatma Gandhi

Everything comes to him who hustles while he waits.

— Thomas A. Edison

Imagine a blind man. If you tell him that there is light in the room, he could answer, "I can't touch it, I can't smell it, I can't taste it and I can't even hear it. Therefore, light doesn't exist. You are imagining things." Our perceptions have boundaries. Our visual apparatus is not enough when we try to peep beyond these boundaries. In fact, this apparatus which served us very well to view things within our perceptual perimeter might just disallow us any vision beyond our boundary. We might become like this blind man. Negating something because it is beyond one's perceptual prowess to recognise it. Please read what follows with an open mind and *open eyes*.

In the life of a leader, I discern three stages:

Stage 1: When he becomes a leader. This is usually a function of not only his competence but also his fortune. On reaching here, many leaders move to stage two.

Stage 2: In this stage, he becomes a good leader. He now has the capacity to love as well as to reprimand. Usually, in this stage, he develops an awe-inspiring personality. Most leaders do not proceed beyond this stage. Only a handful from among them move to stage three.

Stage 3: In this stage, the leader becomes so established in his rhythm that Nature starts doing his bidding. What he desires, happens. He doesn't need to pull out his sword. His rhythm somehow brings about the outcomes that he prefers. No doubt, his reputation as a skilled warrior in Stage 2 also prevents people from crossing his path. But it is more the beat of his drum that has brought him in harmony with the universe that is at work. The universe is doing his bidding.

Similarly, I discern three types of fates that operate in the lives of men.

A wide majority of people participate in the race of life barefoot. Nature gives only a few the means to acquire a horse. They then have to train the horse, learn horse-riding and participate in this race of life on a horseback. For a minuscule minority, chariots come. They don't have to run barefoot, they don't have to buy or train a horse. Their chariots arrive; they board their chariots and participate in the race of life smelling the roses. It is not that they have done nothing. They have borrowed from the Stage 3 leader. They have borrowed from him the Tao. Naturally, its power is also at their disposal.

Other than preparation, what helps one to materialise and spot these chariots? Perhaps it is kindness and sensitivity. Kindness will help your chariots arrive. Sensitivity will help you spot them. Your sensitivity will also help you realise that you, sometimes, unknowingly come in the way of the universe. You prevent it from playing your song.

Try this experiment. In a serene moment, gaze at the stars. If you are sensitive and lucky, you will be able to spot your connection with them. Don't begin this experiment with aggression. If you begin with the determination to succeed in this communion, you will miss it. Remember, the bird of paradise alights only on the hand that does not grasp. Don't even go with an expectation. Else, your impatience will ruin it. Go effortlessly; float. The connection will reveal itself to you. If you don't succeed the first time, try again, not stubbornly; but as a toddler who is trying to climb a step. If you fail, try again without frustration, just as he did the first time. If you try to connect with this attitude, the connection will establish. This connection is real, waiting to be discovered by you.

Such communion, with stars, mountains and, rivers could help one develop some kind of cosmic consciousness, making him aware of the true life and order of the universe and feel oneness with the universal energy.

This external communion will change you internally too. The wave experiences something on the shore. As it returns, it carries this something back to the sea. The sea will change too. These changes in your external and internal worlds will help your chariots arrive and will help you spot them.

Deep knowledge of the situation coupled with understanding the rhythm of the universe helps one ride on the natural patterns effortlessly. Brilliance is when you can see what others can't see. Genius is when you can fathom what others can't even imagine — the unique ability to grasp the subtle and the hidden. The genius even almost knows what the future holds. So through his efforts, he positions himself at a precise spot and soon enough the victory stand emerges from the earth beneath his feet. He responds humbly to the applause that follows, because he realises that his effort is responsible for this victory, but only in part. Then, he decides on his next destination.

His next trip also resembles the previous one. He perseveres in his efforts but he doesn't insist. There is a difference in persevering and insistence. If you insist stubbornly to get something that is beyond your depth, your obstinacy will prove futile, at worst damaging. It may even bring misfortune. Action is not always lucky. Sometimes it is better to guard your energy and wait for the precise moment to unleash it. There is a time and place for everything. The genius can smell time. He can distinguish between the time for patience and the time

for rigorous action. His antennae are tuned in. He is in sync with the universe and in sync with Nature. He is not only decoding the notes but also enjoying the music.

He prays as he performs. This blend of perspiration and prayer produces spectacular outcomes. I call it holy sweat. The one who perspires so knows the powers of the universe are beyond his imagination. What we call miracles is routine for the universe. He uses the momentum of this routine to supplement his efforts. Du Mu, the Chinese military strategist, had said, "Roll rocks down a ten-thousand-foot mountain, and they cannot be stopped; this is because of the mountain, not the rocks." He is using the momentum of the universe.

Wisdom is knowing yourself and others; enlightenment is knowing the universe. The great are both wise and enlightened. That is why their conquests are absolute.

SELECT BIBLIOGRAPHY

1. Robert Greene and Joost Elffers, *The 48 Laws of Power*, Viva Books, New Delhi, 1999.

2. Jeffrey Pfeffert, *Managing with Power*, Harvard Business School Press, Boston, 1992.

3. Nigel Blundell, *The World's Greatest Scandals*, Octopus Books, London, 1986.

4. Patrick French, *Liberty or Death*, Harper Collins, New Delhi, 1998.

5. Stanley Foster Reed, *The Toxic Executive*, Random House Value Publication, 1994.

6. Sue Black Hall, *The World's Greatest Blunders*, Bounty Books, 1997.

7. Harriet Rubin, *The Princessa : Machiavelli for Women*, DTP, 1998.

8. Chin-Ning Chu, *Thick Face Black Heart*, Warner Business Books, 1994.

9. Shirley Peddy, *Secrets of the Corporate Jungle*, Jaico Publishing House, Bombay, 1997.

10. Dr Lawrence J Peters, *Peters Quotations — Ideas for Our Time*, Bantam Books, New York, 1977.

11. Miyamoto Musashi, Thomas Cleary, *The Book of Five Rings*, Shambhala, 2003.

12. Sheetal Kumar Jain, *The Book of Great Errors*, Pustak Mahal, Delhi, 2001.

13. Donald G. Krause, *The Art of War for Executives*, Perigree, New York, 1995.

14. Ralph D. Sawyer, *Military Methods*, Westview Press, April 1995.

15. Michael A. Ledeen, *Machiavelli on Modern Leadership*, St. Martin's Press, NY, 2000.

16. Paulo Coelho, *The Devil & Miss Prym*, Harper Collins, London, 2001.

17. Neale Donald Walsch, *Conversations with God*, Hodder and Stoughton, London, 1996 .

18. Clifton Fadiman, Little, (Ed.) *The Little Brown Book of Anecdotes*, Brown and Company, 1985.

19. Will Durant, *The Story of Philosophy*, Pocket Books, NY, 1953.

20. Joe Hyams, *Zen in the Martial Arts*, Bantam Books, NY, 1982.

21. Ralph D. Sawyer, Mei-Chun Lee Sawyer, *The Art of the Warrior*, Shambhala, 1996.

22. Robert B. Cialdini, *The Psychology of Persuasion*, Quill William Morrow, NY, 1993.